ARTISTS
CONFRONTING
THE
INCONCEIVABLE

Award Winning Glass Sculpture

Edited by

Irvin J. Borowsky

AMERICAN INTERFAITH INSTITUTE

Philadelphia

CONTENTS

DEDICATION

Artists Confronting the Inconceivable
is dedicated to the memory of Anne Frank
and the two million Jewish and Christian
children of Europe who perished in the Holocaust.

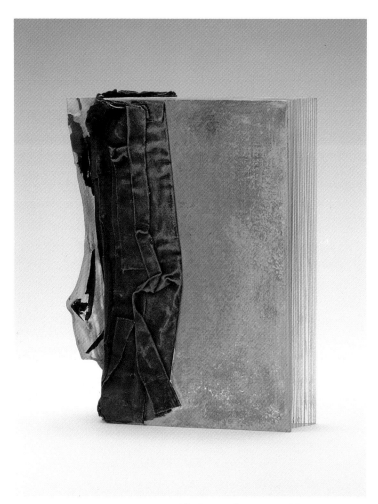

The Diary of Anne Frank by Pam Gazale

*Wherever books are burned,
there also, in the end,
people are burned.*
—Heinrich Heine

FOREWORD

AS A MEDIUM, GLASS HAS UNIQUE CAPACITIES TO EXPRESS human feeling and to foster the art of memory.

In remembrance of Kristallnacht and the events of the Holocaust, the American Interfaith Institute invited glass artists to create work that would illustrate the ravages of prejudice and hate. Over 1000 entries were received from artists in 28 nations.

One of the most remarkable aspects of this project has been the personal commentary that accompanied each entry. The artists' words offer passionate perspective and provide an additional dimension to their work.

Seeing the events of the Holocaust through the eyes of artists enlightens the dark side of the world. In our time, it has frequently been their vision that has moved righteous people to think about the implications of the choices they make and the relevance of these choices to society.

The Holocaust is humanity's most devastating expression of hatred. The premeditated murder of millions of Europeans has no parallel in the annals of human barbarism.

The Holocaust raises a question: in an "enlightened" era, if it happened once, can it happen again? We are reminded daily that no people, no nation, has immunity against the forces of bigotry and intolerance. As long as people are victims of prejudice, the battle against hate must continue.

The ultimate end of prejudice is murder. The most innocent and helpless victims are children. This volume is dedicated to Anne Frank and the two million other children who did not have an opportunity to grow old.

Whether it lies shattered on the street or is prominently exhibited in a gallery, glass is a reminder of both the strengths and the fragile qualities that lie within us . . . and within civilization itself. Clearly, artists examine, define and reflect ourselves and our world. Art expresses that which is most deeply human. The artists whose work fill this volume do not seek satisfaction or revenge, but prevention. They present a mirror that can hallow the past and safeguard the future. Let us absorb their messages carefully and learn from their visions.

Irvin J. Borowsky, Chairman
AMERICAN INTERFAITH INSTITUTE
Philadelphia, Pa.

ACKNOWLEDGEMENTS

WE ARE INDEBTED TO THE ARTISTS WHO RESPONDED FOR NOT RE-
maining silent. In their works and their words they have expressed
feelings, perceptions and horror about that which is past as well as
concern for a future that trembles through the haze of smoke not yet
cleared.

The American Interfaith Institute has presented Gold, Silver and
Bronze awards to each of the artists whose work was selected for
publication in this volume.

Gratitude is also extended to judges and supporters of the project:
Michael Belkin, Simona Chazen, Jerome Chazen, Beverly Cope-
land, Jean Sosin and to Master Artists Dale Chihuly, Tom Patti,
Paul Stankard; to Gerda Klein, the living Anne Frank for guidance;
to Arthur Bodenheimer, translator; to Susanne Frantz, consultant;
to Karen Ganter, project assistant; to Jonathon Nix, designer; and to
my wife, Laurie Wagman, for editorial assistance.

ART IS SPECIAL SPEECH. LIKE MUSIC IT CAN ORCHESTRATE what cannot be conveyed orally. Art can encapsulate the inarticulate; it can point to the inconceivable. It can make the incredible present and memorable.

The scope of the Holocaust, its inhuman violence and horrific repugnance—its inconceivableness—seduces many into thinking it could not have happened. In the nation of Bach, Beethoven, and Brahms, in perhaps the most cultured and sophisticated nation in the history of the human race, the genocide of millions—all innocent and defenseless—is inconceivably incredible. The grotesquely macabre could not have happened in the citadel of learning, we gasp.

But it did.

How can one articulate—put into finite words—the pathos of a mother's tears as she feels her child ripped from her arms? How can one express the horror of a father brutally torn from those whom he was created to protect? How can words contain the awful thought that these mangled naked corpses are our own? With Promethean anger, one faithful to the covenant will be tempted to break the silence of Job and cry out, "Are you there anymore, God? Do you not see? Do you not give a damn?"

Now, in this volume, the inarticulate rage is expressed. The incomprehensible is visually represented. From many nations, artists have come forward to expose their memories. Their tears have crystallized.

A special language appears. It is spoken silently in glass.

Artists symbolize; we remember. The permanence of hardened glass preserves the reflection.

Others—even those of future generations—will certainly remember also and be moved to join us in the commitment that they who died will not be forgotten and that never again will the brutality of those unspeakably horrible acts be repeated.

The Reverend Doctor James H. Charlesworth
The George L. Collord Professor of New
Testament Language and Literature, and
Editor of the Dead Sea Scrolls Project,
Princeton Theological Seminary,
Princeton, NJ

ERWIN EISCH

GERMANY

My Love To Anne Frank

15¼ x 12¼ x 7¼"
40 x 32 x 19 cm
Glass head with engravings, mirrored

GOLD AWARD

THE THEME OF THIS PROJECT IS A RELEASE FOR ME . . . AN opportunity to mull over, digest and regurgitate a collective memory of the Holocaust.

I use the blown head of Picasso as a blank canvas. He represents for me this period of time and the aesthetic annihilation of the human figure. His "Guernica" was actually created one year before Kristallnacht and depicts the brutality that unthinking and unchecked hate can produce.

The engraved symbols of Anne Frank and the Holocaust that I have incorporated into these pieces are and will always be timeless. In these works the viewer must look through them in order to see themselves reflected.

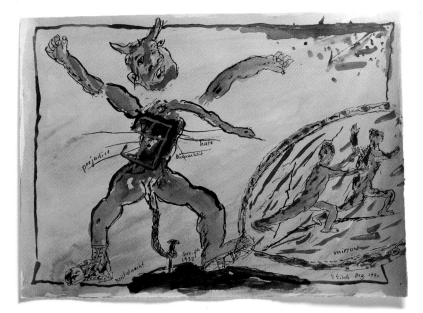

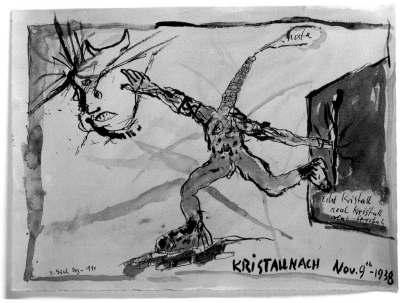

Two drawings from THE KRISTALLNACHT SERIES *by Erwin Eisch*

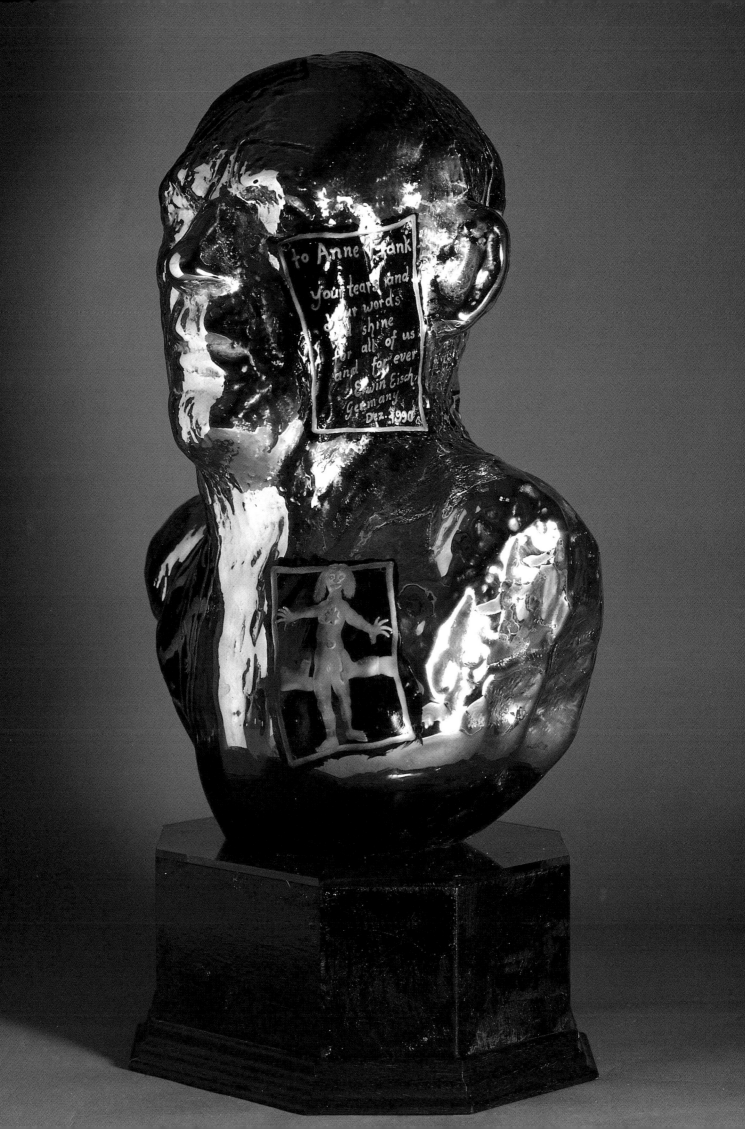

12

STEVEN FEREN

<small>UNITED STATES</small>

*Krïstallnacht: In Memory
of Herschel Grynszpan*

96 x 31 x 84″
249 x 80 x 218 cm
Steel, concrete, glass

GOLD AWARD

CRUELTY AND MURDER COMMITTED AGAINST INNOCENT people . . . a dark and dangerous legacy. The effects of anger, guilt and rage echo through the generations.

This sculpture is about leaping into the abyss. It is a reminder of being forced into darkness. As I am witness, I am victim and must fight against all forces of hate and oppression . . . now and forever.

Each piece of glass that comprises the figure has inscribed upon it the name of a German Jew killed by the Nazis.

The glass book in the piece is a call to the future: the word *Remember* is etched in Hebrew.

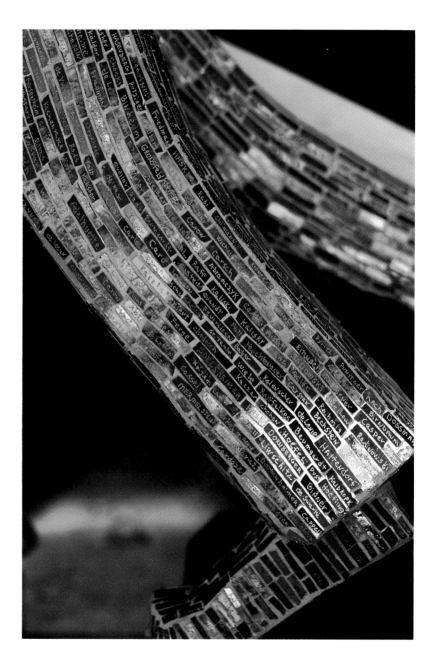

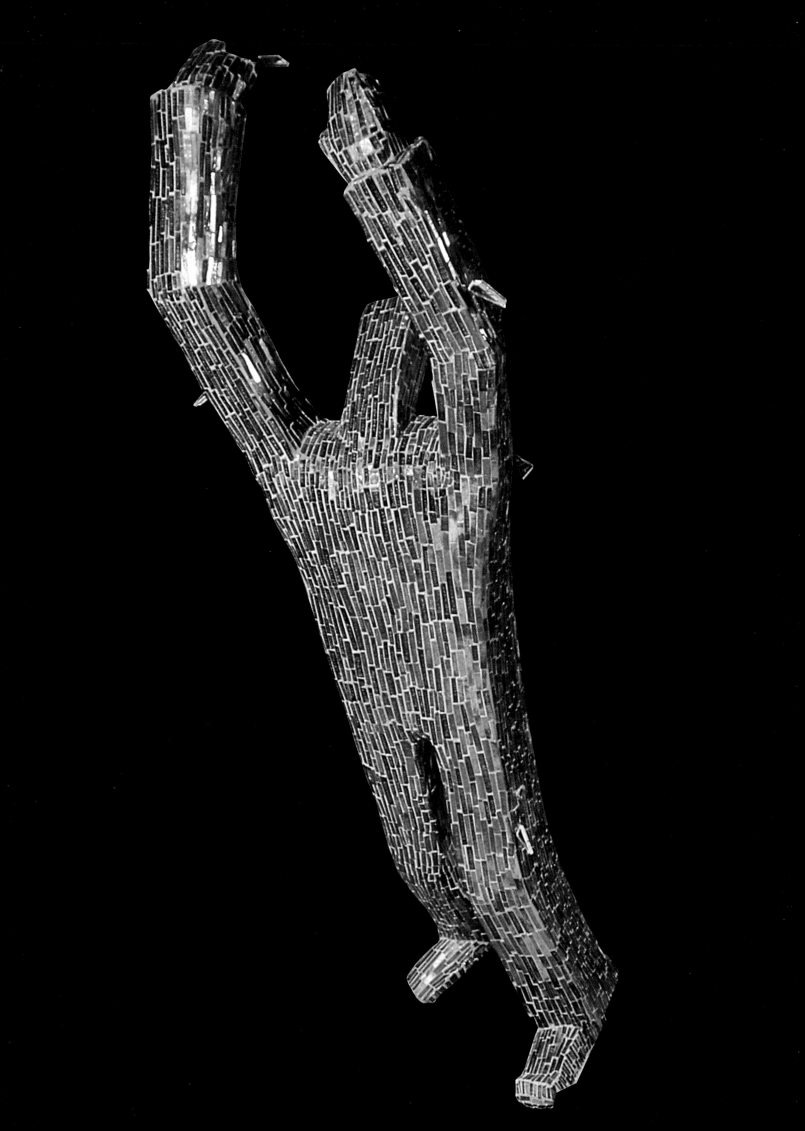

14 **FUMIO ADACHI**

JAPAN

Psalmody

84 x 81 x 63"
218 x 210 x 163 cm
Blown glass with metal stems
and plastic chips covering base

GOLD AWARD

PSALM

Two million children's screams
in the red flame of the Holocaust
becoming like a psalmic chorus
as time passes
echoing in mind forever

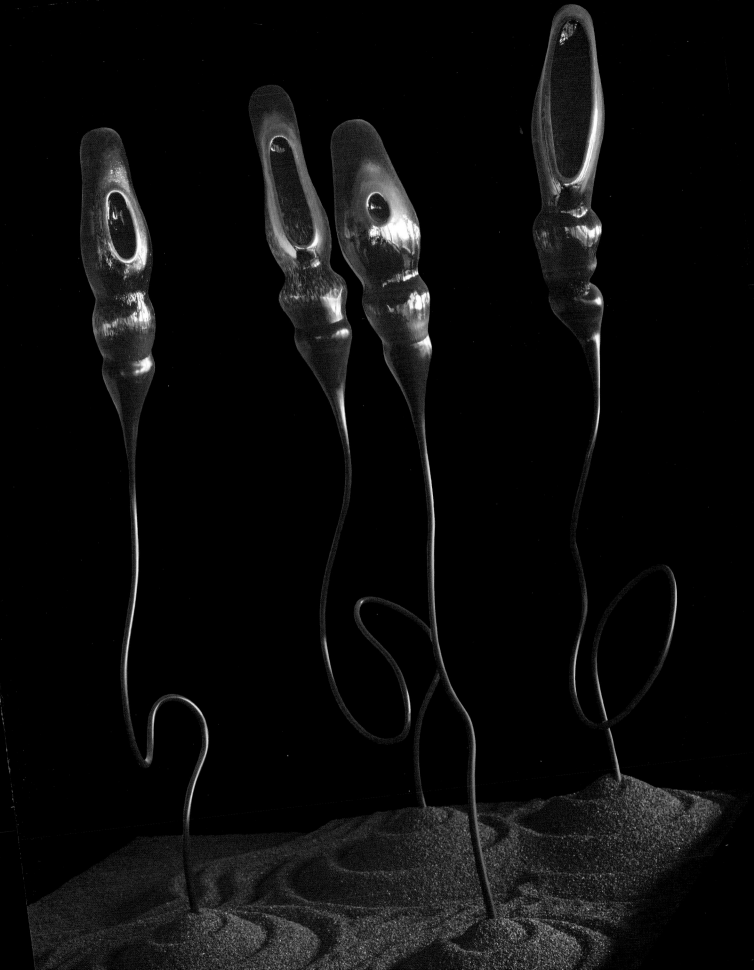

16 **LUCIO BUBACCO**

ITALY

Babi Yar

20 x 1¼″
52 cm diameter x 3 cm high
Lampwork figures on blown plate

GOLD AWARD

ON SEPTEMBER 19, 1941, THE ADVANCING GERMAN ARMY captured Kiev, the capital of the Ukraine. Within days an order was posted in Ukrainian and Russian:

> *"Yids of the city of Kiev and surroundings! On Monday, September 29, you are to appear by 7:00 a.m. with your money, documents, valuables, and warm clothing at Dekhtyarev Street, next to the Jewish cemetery. Failure to appear is punishable by death."*

From the cemetery, Kiev's Jews were marched to the ravine of Babi Yar, two miles from the city. There they were forced to strip—men and women, boys and girls, old and young. The Nazis were meticulous; no material was wasted. Clothing was gathered and folded. Other belongings were placed in adjacent piles. At the edge of the ravine, the naked Jews were mowed down by automatic fire.

In the days between the Jewish holidays of Rosh Hashanah and Yom Kippur, in 1941, entire families totaling 33,771 Jews were murdered at Babi Yar. In the months that followed, Babi Yar remained an execution site. Soviet reports after the war speak of 100,000 murdered. The true number may never be known.

I remember the first time I saw photos of the mass graves was when I was just a child of 14. I remember hearing about Babi Yar and the families and children. This work recalls their final contact . . . their last touch with life. It is their reaching, both physically and spiritually, and the contact—of one body to the next—with the next . . . the lifeless limbs, distorted, broken and heaped with such disregard one on top of the other in a massive grave . . .

The red is not from the glow of the sun. It is their blood which flows together.

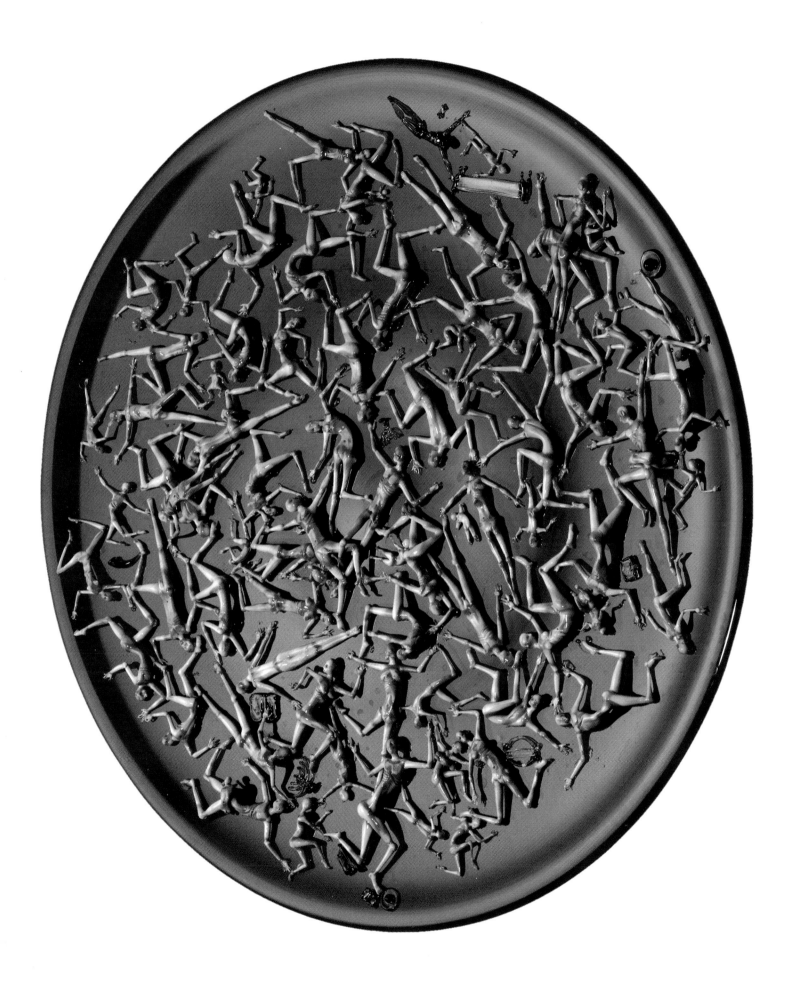

JIRI HARCUBA

CZECHOSLOVAKIA

Self-Portrait

36 x 36 x ½"
93 x 93 x 1.3 cm
Engraved glass

GOLD AWARD

THE CREATIVE EXPRESSION OF ARTISTS IS FEARED BY DICTAtors. Rightly so, because art, more than any other communication, encourages people to think and see for themselves.

My own work concentrates on portraits. I am trying to express human destiny and the different characteristics of people.

In portraits of outstanding men of the past and present time, I seek symbols of excitement, sadness, tragedy.

When members of family, close friends and other contemporaries are portrayed in my work, I am expressing my understanding as I see them.

This self-portrait is one of contemplation. The Japanese speak of "soshin". . . a beginner's mind. I accept that attitude completely. Let us be open again and again . . . to see everything as new, to liberate ourselves, to be tolerant, to accept life as a piece of art. It is an endless way of discovering.

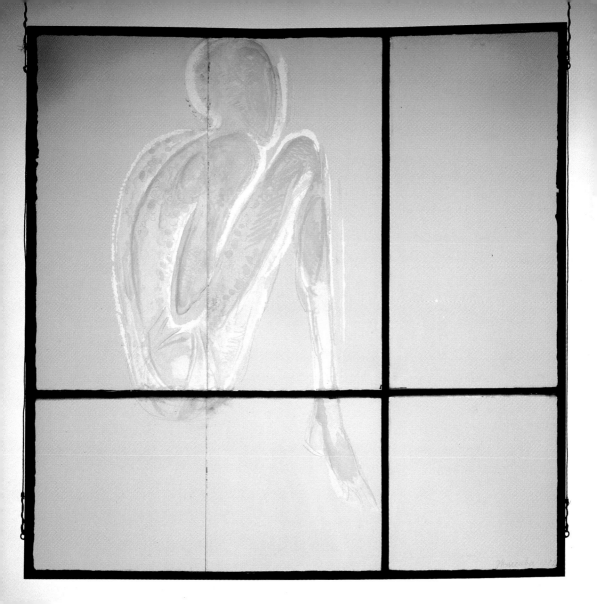

TOAN KLEIN

CANADA

Listen to the Flames

20 X 52 X 22"
51 X 132 X 56 cm
Gatographs (patented encased
photo-silkscreens in glass),
sandblasting, dalle du verre,
hot tooled glass, blown glass,
acrylic wicks, silicone

GOLD AWARD

THIS SCULPTURE COMMEMORATES NINETEEN PEOPLE IN MY family killed during the Holocaust. They were all Lithuanian Jews. This is the only memorial that exists to record their lives and deaths.

It is hard to relate to six million murders. The disturbing photos we've seen of mounds of bodies or emaciated prisoners in striped clothing can be alienating. Therefore, I have tried to go beyond the general to the specific, and to make something beautiful and alive out of something horrible and deadly.

The individuals in this memorial were full of life and enthusiasm. They were ordinary working people: a watch-maker, an office clerk, a goose-farmer, the operator of a horse-driven grain mill, housewives, schoolchildren. They lived in the villages of Vishtinetz, Neinshtot and Kibart in Lithuania.

These people were systematically rounded up by the Nazis. Some were shot at once; others were made to wear a yellow star, and were later shipped off to their deaths in concentration camps—principally to Dachau in Germany. My Lithuanian-born mother and her immediate family, through a series of lucky events, left Europe before the war broke out. Virtually all of the relatives they left behind, including my great-grandparents, were killed.

The encased photos were obtained from various family albums. No pictures exist of two people, but their names and faces survive in the memories of a few older folk. Each person is depicted as a candle. The candles are arranged in rows of seven (the days of the week) and twelve (the months of the year) to represent the time they never had. The large central candle or "shamas" encases a well-known image from Yad Vashem, the Jerusalem Holocaust Martyrs and Heroes Remembrance Authority. It serves to help us imagine more precisely what happened to these people.

Through the shamas can be seen an oil-burning "yahrzeit" lamp. This is traditionally lit on the anniversary of a loved one's death. The flame will burn for eighteen hours before the oil chamber empties. In Hebrew, the word for eighteen—"Chai"—is also the word for "life."

Scattered around the memorial are shards of glass in remembrance of Kristallnacht. Each chip has been etched with the words "the children" in different European languages. Children of all nationalities and religions fell victim to the Holocaust. Some lost their lives; others, their childhoods. The terror they endured seeing parents, grandparents, aunts and uncles killed, dragged away by soldiers, beaten or tortured, affected them forever and has had a lasting effect on their own children.

The "call for entry" for this Kristallnacht exhibition acted as a catalyst for this memorial to my lost family.

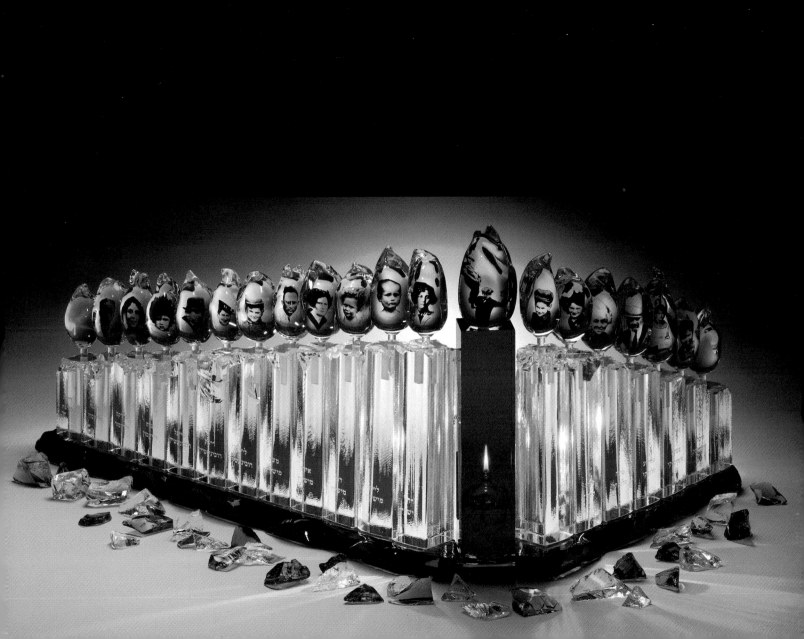

EDWARD LEIBOVITZ
BELGUIM

Homage to Sound

24 x 13 x 11½"
62 x 35 x 30cm
Cast, engraved, sandblasted glass

GOLD AWARD

The sound of millions of windows broken apart, a terrifying sound revealing the Holocaust, unforgettable in its horror, unforgettable in glass.

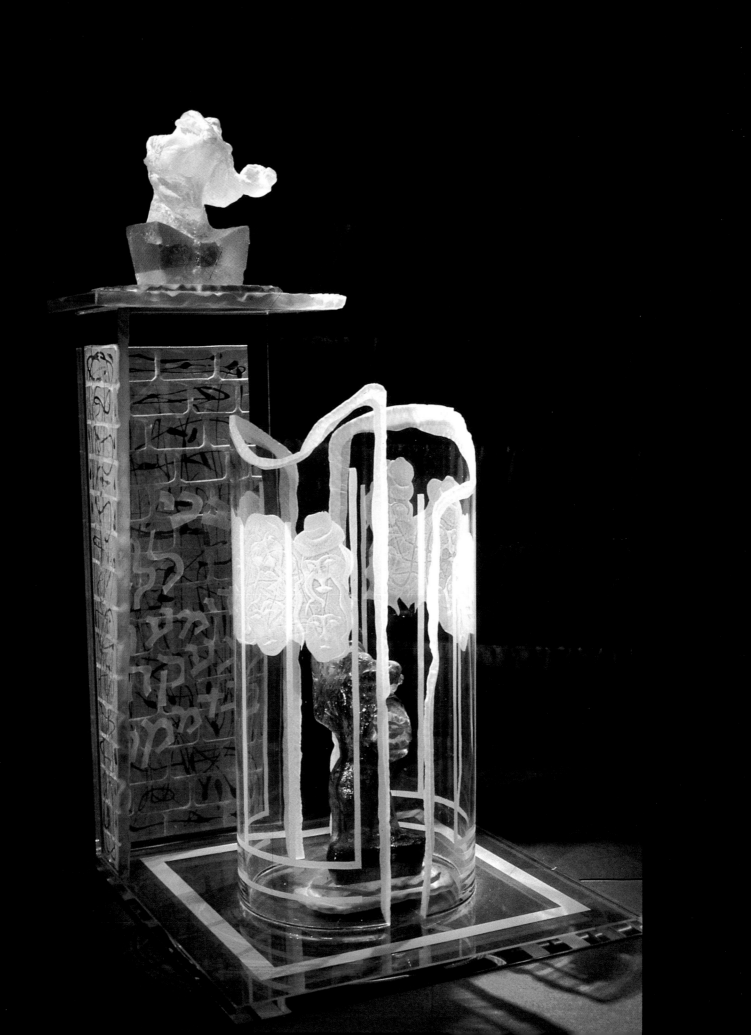

STANISLAV LIBENSKÝ & JAROSLAVA BRYCHTOVÁ

CZECHOSLOVAKIA

The Last Emperor

21 X 28 X 10"
52 X 70 X 25 cm
Cast glass

GOLD AWARD

THE SCULPTURE "THE LAST EMPEROR"
arose as a thought on the tragedies
and the hopes of this century.
The kind of glass which was chosen to express this idea
gives a color which alternates
between the brown of the ashes and the ruins
and the sky blue of the renewed belief in man.

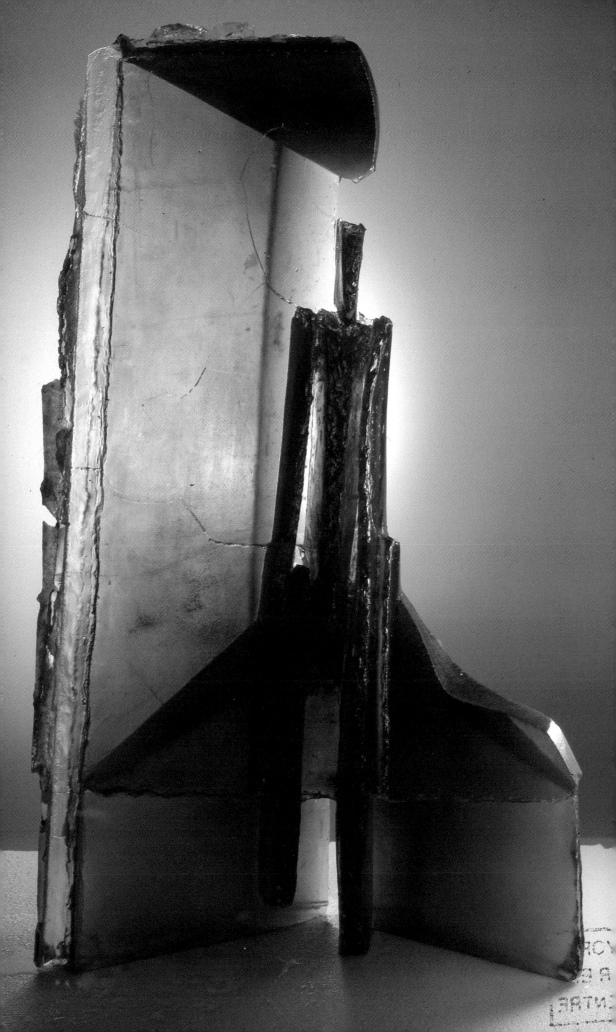

MARIA LUGOSSY

Hungary

Inclusions

EACH CUBE IS
11¾ x 8⅝ x 9½"
30 x 22 x 24 cm
Grey glass sheets, laminated, cut, sand-
blasted, polished bronze incorporated

GOLD AWARD

ALTHOUGH EXISTENTIAL ANGUISH IS,
and has been, an increasingly somber
artistic pre-occupation in this century, my
own concerns are more recent.

Perhaps my gradual artistic maturation
has sensitized me towards human suffering;
or, perhaps, I have been influenced by
cosmic existential dilemmas highlighting the
human predicament in a parabolic fashion.
I am not sure.

But, I am sure that human cosmic slavery
has somehow paralleled suffering; or,
perhaps the plight of Jewry has symbolized
the overall human condition worldwide
throughout many weary centuries.

Thus, the Holocaust, in which Jewish
suffering reached its crescendo, may be seen
as the epitome of a cosmic existential denial
of hope which is absolutely devastating.

For hope is all we have—because we are
humans and that is all we are.

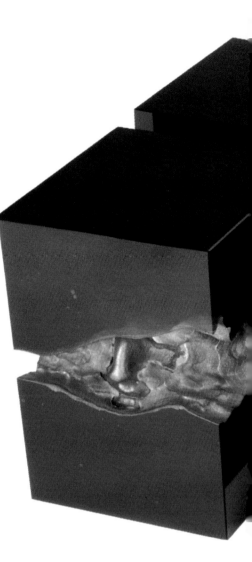

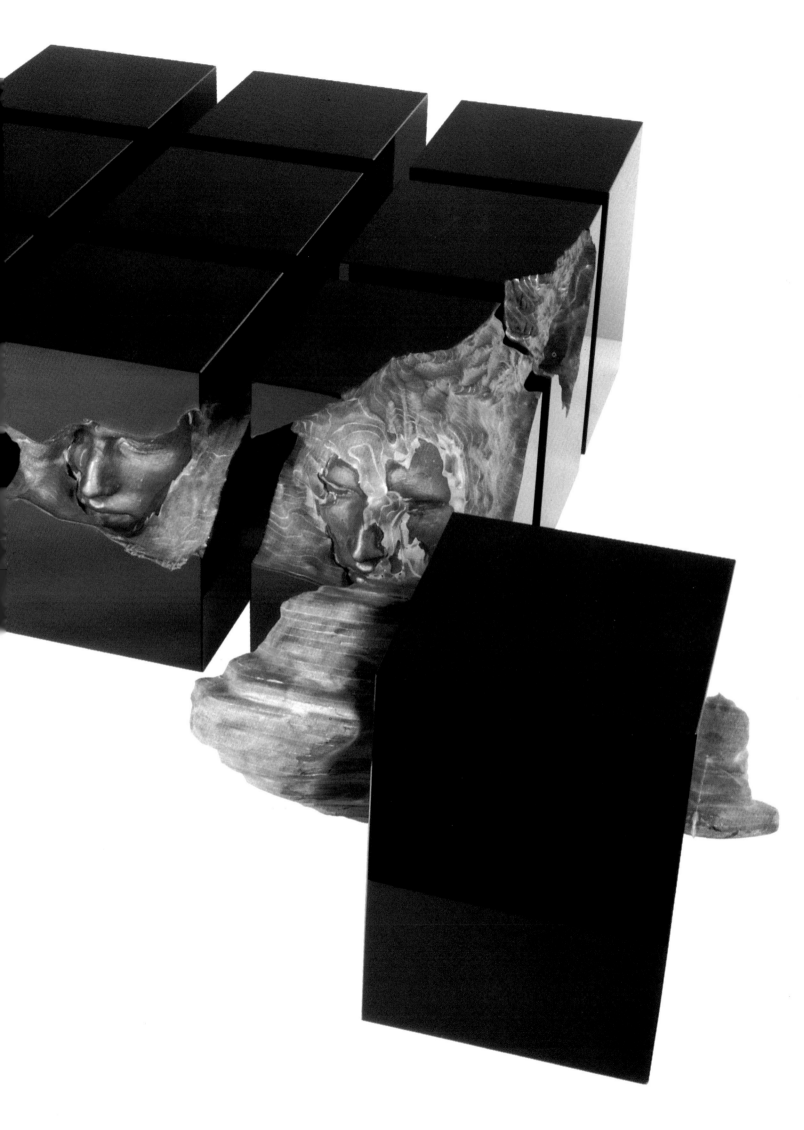

FINN LYNGGAARD

DENMARK

Lest We Forget

24½ x 23½ x 11"
64 x 60 x 28 cm
Sand cast figure, heat-formed white
glass, flat blue glass, reinforced glass,
mounted on an oak wood base

GOLD AWARD

I WAS BORN IN 1930—THE YEAR HITLER TOOK OVER AS Fuhrer of Germany. The German invasions of 1939 and 1940 left a powerful impact upon my childhood memories.

From that moment all changed. Even for a 10-year-old boy, it was obvious that the happy childhood was over, and the world never again was going to be the same.

Throughout Denmark, during the era of the Holocaust, it was well known and clear to us that unbelievable atrocities and terror were taking place in other countries in Europe. By secretly listening to broadcasts from BBC in London, we were able to follow the rapid destruction of Europe and learn about the persecution of innocent civilians in occupied countries.

Other events: the disappearance of Jewish families or friends of whom the more lucky ones managed to escape to England or Sweden; the execution of young Danes from the underground movement; the fact that I had an elder brother in the same movement—a secret that you dared not share even with your parents or your closest friend; the shocking and unbelievable information about German atrocities in the KZ-camps which you received through the illegal underground press—all these things and many others left in a 9-10-year-old boy's impressionable memory a never-erasable picture.

The full impact of the extent of the Holocaust and the genocide upon millions of innocent people did not reveal itself until the spring of 1945 when the Red Cross buses started bringing home the survivors of this inferno. The image of these poor starved and tortured men and women—looking almost inhuman with their shaved heads and sunken eyes in exhausted and yet, happy faces—returns to my memory whenever I think of the war years.

In 1945 all the shocking revelations of the full truth finally became known to the world. In years to follow, books and articles supported the immense extent of German cruelty. It took me many years to establish a relaxed relationship with German people and to the country itself. In fact it was not until many years later when a new and, hopefully, unblemished generation was beginning to outnumber the old Nazis that I could overcome my reluctance to speak with Germans and, later still, to visit the country.

Even today, after having read many books about that time, I still have not reached an understanding of how all this could happen. But maybe I have learned the lesson that whenever minorities are pursued or oppressed because of race, creed, skin color or for any other reason, we must all be on our guard. In Germany it started with the Kristallnacht and without the rest of the world lifting a finger or protesting. But never again must there come a night like

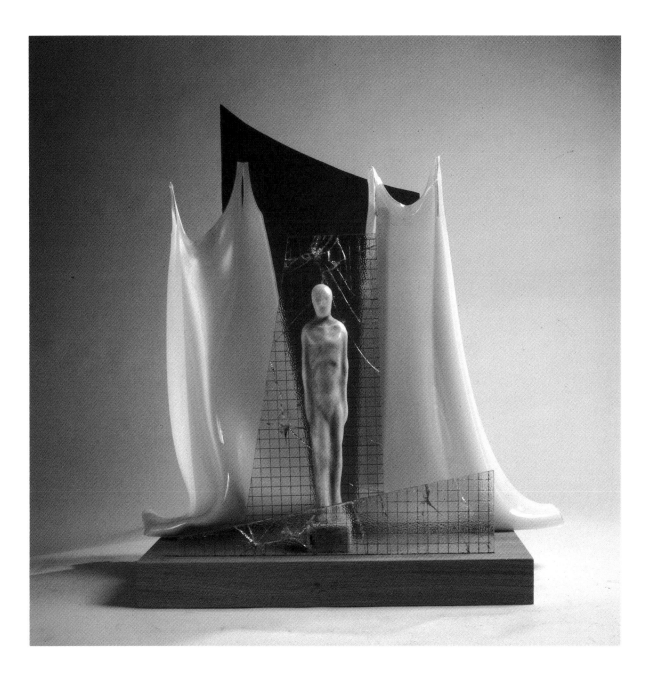

this without the whole civilized world uniting and shouting "NO! *No Kristallnacht!*"

Apart from reflecting the beauty and magnitude of our world, the artist has an equally important obligation to show the darker sides of life. This has been the impetus for my participation in this competition—*lest we forget*!

URSULA MERKER

Germany

*Open Drawers,
Hidden Memories*
(an installation)

11¾ x 2 x 19½ x 32"
40 x 80 x 50 cm
5 lead crystal hemispheres (each 40 cm
diameter) sandblast and hammer en-
graved in wooden trays 50 cm x 80 cm

GOLD AWARD

Like open drawers, the trays show images that have been stored in our heads. They present, for our examination and exploration, a past that can never be hidden away . . . that can never be forgotten. The drawers must always be kept open to show new generations the insanity that made the facts behind these images possible; to remind them of the hate that lies just below the surface. Only by reflecting on the reality of the caskets can we hope that Kristallnacht and the terrors that followed will not be permitted to happen again.

The five caskets show events in the life of a mother:

Drawer 1
The loving protection of the arms of a mother shields her child from the mindless ostracism of their neighbors. The mother embraces the child. The menorah is the symbol of the family's faith.

Drawer 2
The father recognizes the hideous threat imposed by the swastika and tries to protect his family. Their faces are terrified, and their defending arms bear the mark of the Star of David.

Drawer 3
The father is ripped from his family, and they are interned in a concentration camp. Father, mother and child are lined up in a queue of prisoners.

Drawer 4
Amidst chaos the child is separated from the mother. In an extermination volley, its face, hands and arms are seen groping for rescue.

Drawer 5
The mother's survival of the horror leaves her with empty arms. They want to give love again, but can only embrace emptiness. She remains veiled in memories of the terror.

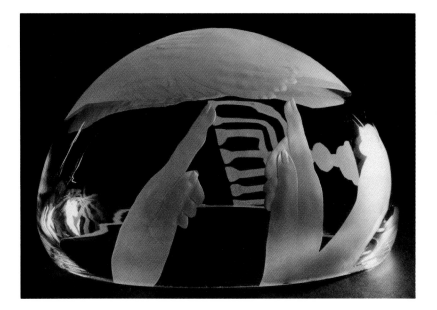

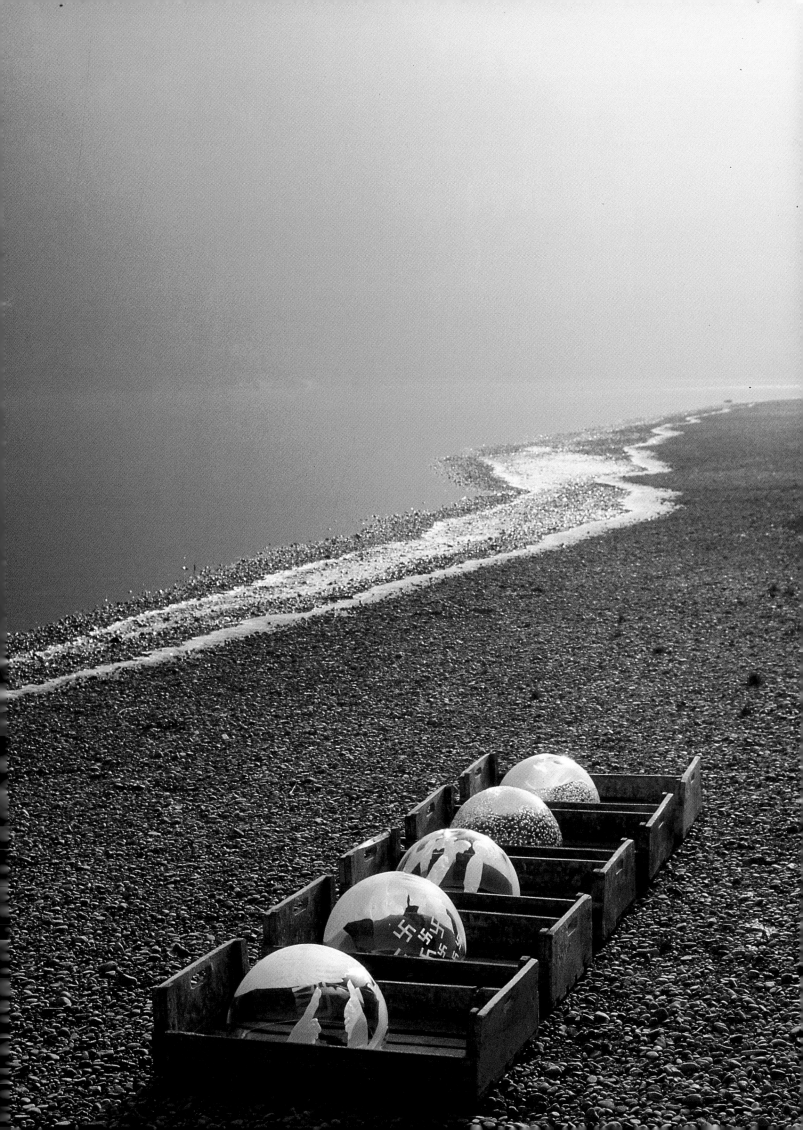

LIOUBOV SAVALYEVA
RUSSIA

Sorrow

Male Figure: 19 x 5 x 3″
48 x 12.5 x 7.5 cm
Female Figure: 16 x 7 x 4½″
49 x 13 x 7 cm
Blown glass

GOLD AWARD

MY WORK IS DEDICATED TO MY BRAVE COUNTRYMEN WHO suffered beyond human endurance during the Holocaust period. Millions of civilians were murdered outright. Throughout the siege of Leningrad, hundreds of thousands more froze to death, died from starvation. The courage and fortitude of the populace in the face of the tragedies that surrounded them was the element that led to hope and survival.

The two figures in "Sorrow"—one sitting, one standing—have a hollowed out quality. But they are still translucent. They catch the light. There is still room in their lives for tomorrow.

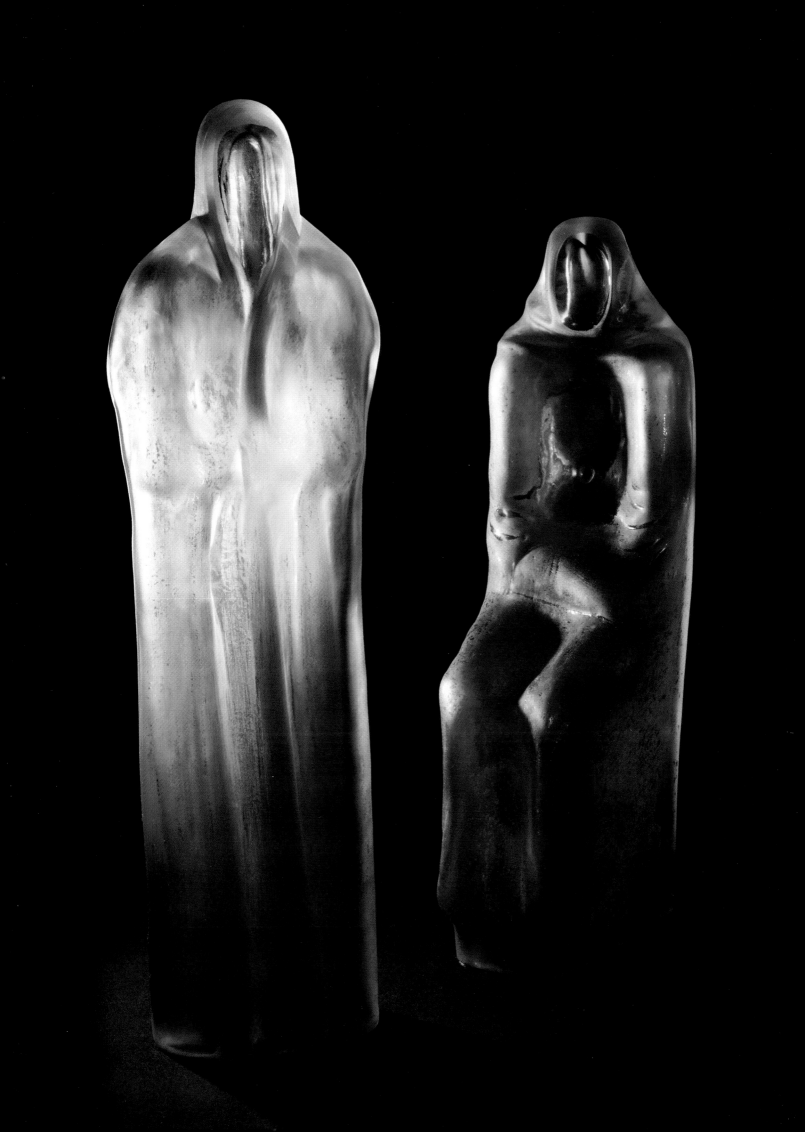

ELLY SHERMAN

UNITED STATES

The Book of Sorrow and Hope

Glass, stone, enamels, sculpture,
painting, writing
6 panels
each 18 x 12″
46.6 x 30.4 cm

GOLD AWARD

MY WORK INCORPORATES GLASS, STONE, PAINT, PAPER AND gold leaf and quotations from sources as diverse as the Bible, Mohandas Gandhi, Anne Frank, Pope Boniface VII, Chief Sa-Go-Ye-Wat-Ha, Commander Hoesse and the Rev. Martin Luther King, Jr., among others.

Some of the panels deal with the sorrows, tragedies and terror of hatred and oppression. And while the main thrust is the portrayal of the Holocaust of which I am a fortunate escapee, it does not ignore the fact that these tragedies have been, and are, universal. That is the reason behind the blue head on page 3. Were he black, he would not be brown; were he brown, he would not be white; etc. So he is blue and stands for all humankind. Only his nostrils are touched with red, for they hold the breath of life.

The last page is reserved for hope, partly because it seems to me to be the right proportion (1 to 5) and partly because the last page speaks to the future. Only the last sentence on that page is my own: *"Hope is the cool water in the desert of sorrow."*

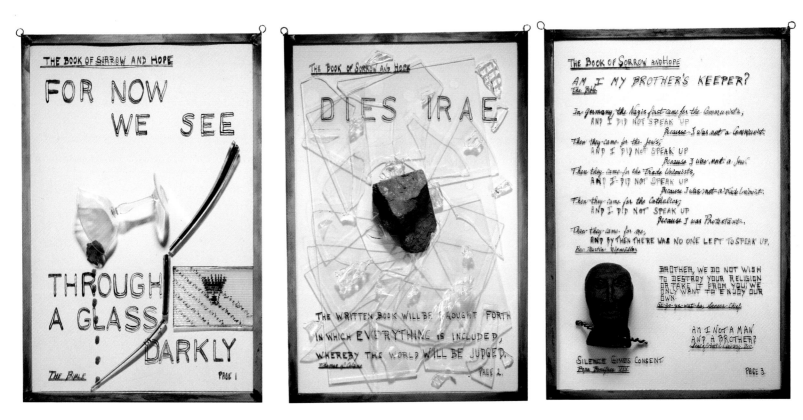

This, then, is my attempt to contribute to the memory of all victims. In the time frame of my own life, many were not as lucky as I. For it was not goodness not talent, not merit, not intellect, but chance that often decided who was to live and who was to die.

Throughout this 4-month-long project, I was haunted by memories of my own encounters, escape and survival, and by thoughts of those who did not make it. But I was even more haunted by the thought that my art form—making books as works of art—was the ideal medium for this message. Books stand for some of the best in human thought and experience, and books are also among the first to be destroyed in evil times.

I am glad to have made *The Book of Sorrow and Hope.* I am proud of it. But I shall never make anything like it again. Too much sorrow, too many tears.

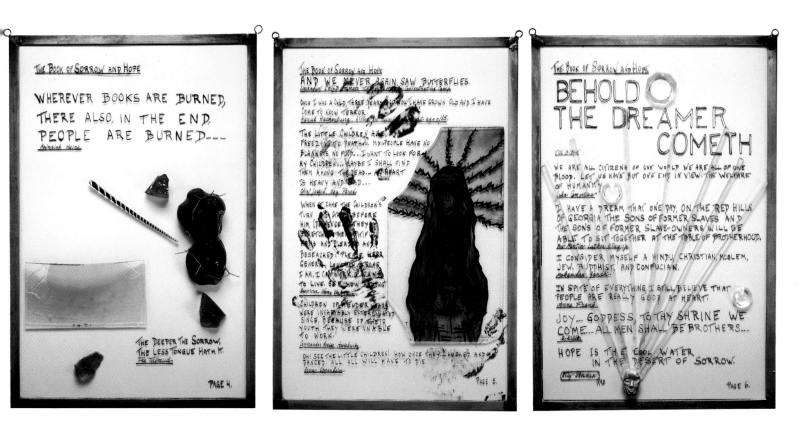

36 **RAQUEL STOLARSKI-ASSAEL**

MEXICO

Never Again

38 x 51 x 20″
97 x 130 x 51 cm
Sandblasted and laminated plate glass
over rock and smashed tempered glass
pedestal

GOLD AWARD

My name is Hafling. It means prisoner. I am Jewish. I have been dispossessed, humiliated, enslaved, abused. My body, diminished to bones, only faintly resembles that of a person. My pregnant womb was ripped and is void. My child will not be born.

Along with 6 million others, I was murdered, my world reduced to ashes. Let my last breath bear witness to the human hatred that is capable of shattering other fellow beings like glass.

Working on this sculpture was a deeply emotional experience. For many years I read about the Holocaust, saw film and photos, listened to survivors. I realize now that for all the information, the caring and feelings I held, I never even glimpsed at a gut level the barest monstrosity of the Holocaust.

Never have I been so shaken as during the intimate process of creating a sculpture that tries to "tell the story"—tell it to those who deny it.

Let us bear witness. This is not only Jewish history. The Holocaust was not the inevitable heritage of man, but the inevitable results of indifference. Let us bear witness: Never Again.

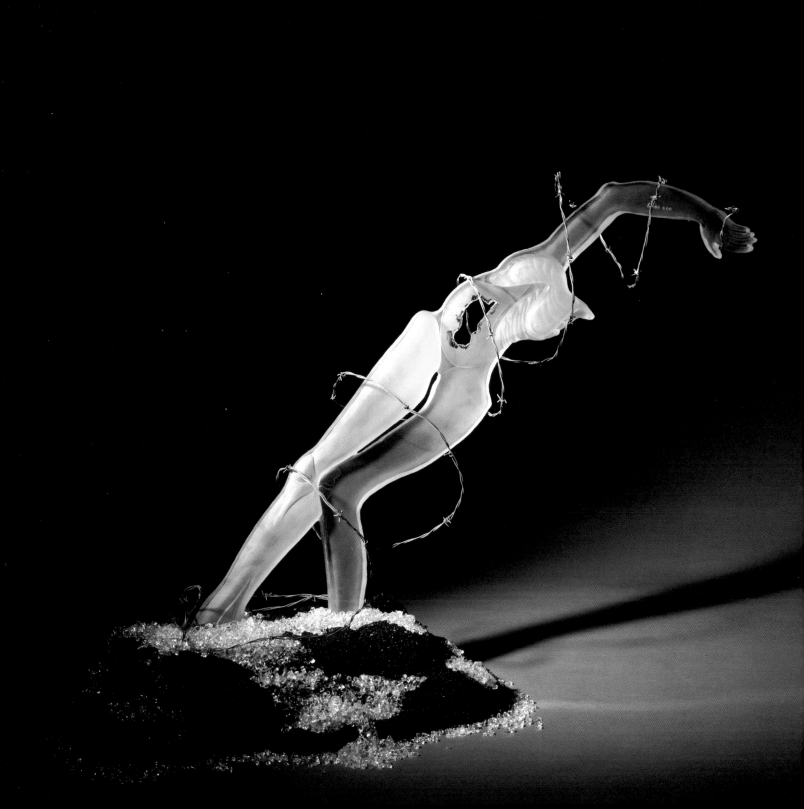

STEVE TOBIN

UNITED STATES

Please Look At Me

29 x 36 x 20″
73.6 x 81.2 x 50.6 cm
Cast glass, cast bronze and barbed wire

GOLD AWARD

FOR ME THE CAMPS WERE ALWAYS THE HARDEST IMAGE TO digest. Death camps. Endless trainloads of people packed like rats in a cage, brought together to die, like animals.

When I close my eyes, I see the luminescent faces of the living dead. Behind barbed wire.

Somehow, by putting the images from the Holocaust that haunt me into one piece of sculpture, I express my pain, horror and sadness to the world.

This piece, entitled *Please Look At Me*, has been created from images of the Holocaust that I have never been able to resolve.

The round cast glass monument is luminescent like the faces of the living dead. The bottom half of the glass has a pattern of boxcars stacked up like bricks in a wall. Above the boxcar wall are 200 faces behind a piece of barbed wire embedded in the glass. The faces are so close together that they become a faceless pattern. To the left of the 200 faces is a man passing into the glass. Above that is a fist extending from the glass, expressing the anger of the Nazis, or the Jews, or maybe my own anger. Above is a ring of angelic faces looking outward. The glass is standing in a cast bronze prison. On all four sides of the bronze are train tracks leading up to the glass. The base of the bronze is composed of bronze human skulls.

I have used the heaviness and harshness of the bronze to imprison the glass. The luminescent lightness of the glass transcends the bronze and barbed wire surrounding it.

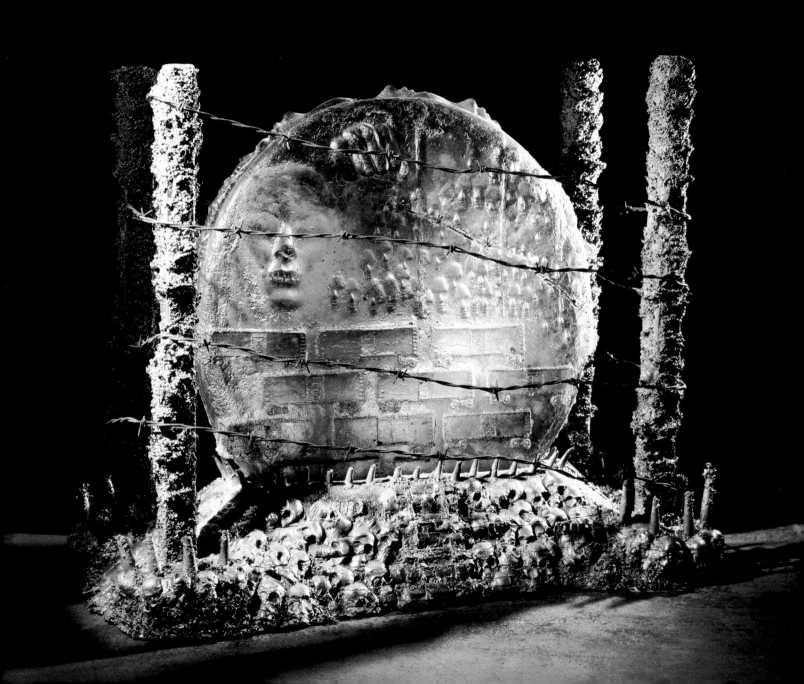

BERTIL VALLIEN

SWEDEN

Exodus

31½ x 13¾ x 25"
82 x 36 x 65 cm
Glass, metal inclusions, sand casting

GOLD AWARD

*"Through an ocean of horror
and acts of inhumanity
a ship,
vulnerable like the thinnest skin,
penetrates the chaos
like an arrow of hope."*

IN SEPTEMBER 1943 A DECISION WAS MADE BY THE NAZI oc-cupiers of Denmark to round up all Danish Jews for shipment to the death camps. Courageously acting on a tip from a German shipping official, Danes from all walks of life mobilized whatever would float and ferried 5900 Jews, 1300 part-Jews and 700 Christians married to Jews to safety in Sweden.

Another act of poignant courage was Raoul Wallenberg, a Swedish diplomat who made it a special, personal mission to help save the Jews of Hungary. More than 30,000 Jews received special Swedish passports from Wallenberg. He set up "safe houses," dis-tributed food and medical supplies and virtually single-handedly set up a bureaucracy in Budapest, Hungary's capital, designed to protect Jews. More than 90,000 Budapest Jews were deported to the death camps and murdered, and Wallenberg's efforts may have reduced the number of those murdered by half.

As a diplomat, he successfully confronted the Nazis at great risk to his own safety. Following the 'liberation' of Budapest by the Soviets, he was arrested by them, thrown into prison and never heard from again. Reports often surface, unconfirmed, that he is still alive, although the Soviets announced his death two years after his arrest.

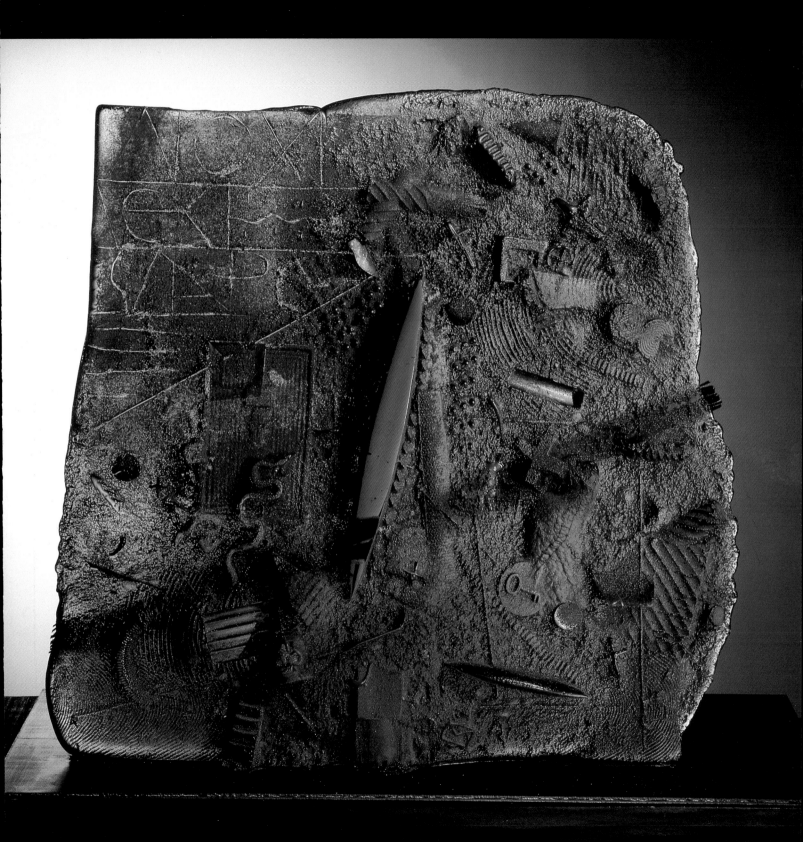

JANUSZ WALENTYNOWICZ

Denmark / United States

Healing

11 x 43 x 23″
28.6 x 111 x 59 cm
Cast glass, oil paint,
metal supported base

GOLD AWARD

*And I listened to my friend,
interested, knowing that I would never fully comprehend.
His sadness had built my anger.
"They believed," he had said.
"Not just obeying orders, they believed."
Cattle, worthless, unwanted!
Recalling his words walking home that night,
I was frightened by the capacity of the human mind.
My friend was still healing.*

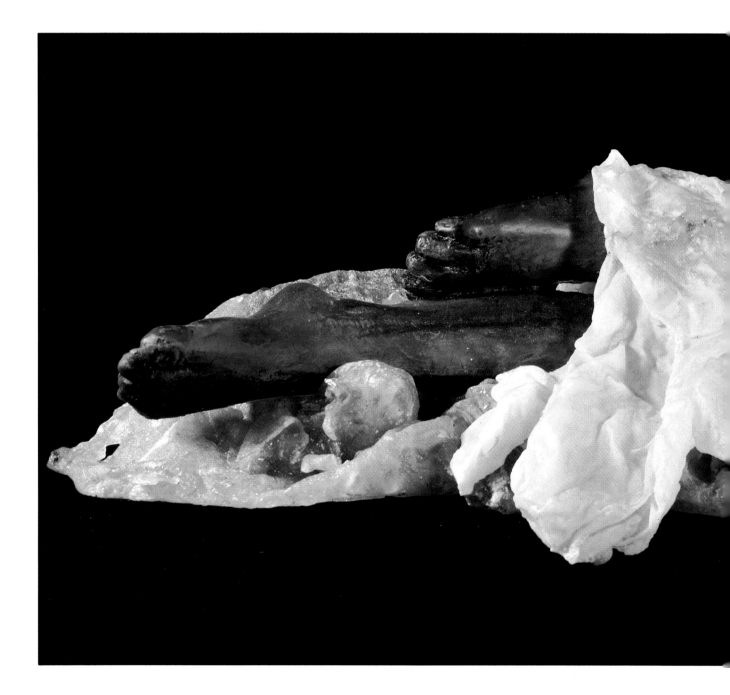

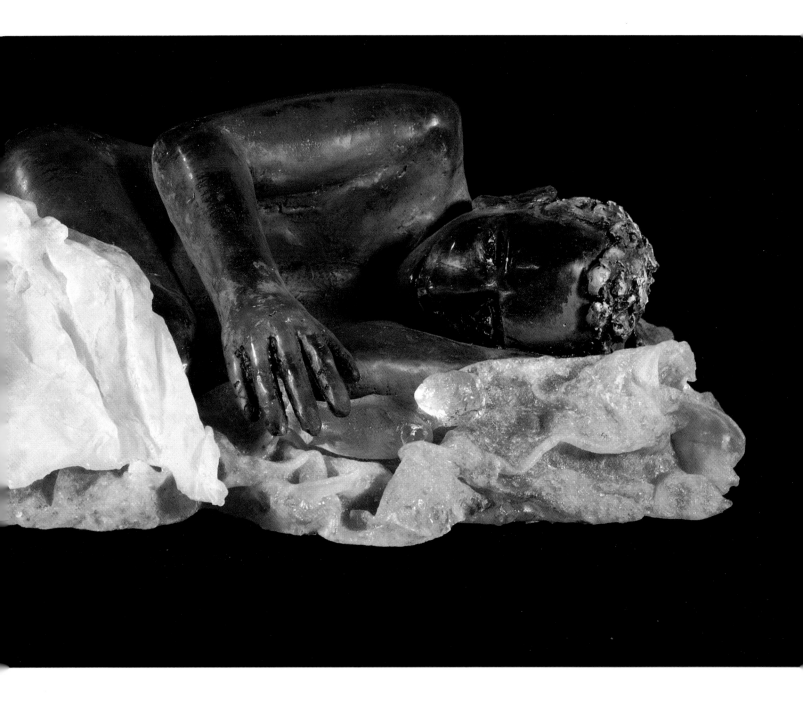

44 **DANA ZAMECNIKOVA**

Czechoslovakia

Old Photograph

18 x 14½ x 18″
46 x 37 x 46 cm
Painted, engraved, cast laminated

GOLD AWARD

FOR QUITE A LONG TIME I HAVE WORKED ON A SERIES TITLED "Portraits in Glass." In particular, I have been haunted and interested in Anne Frank's young, beautiful face. It reflects hidden fears, wisdom and a profound depth of human experiences that we usually only find in people towards the end of their lives.

Although I did not live at the time of Kristallnacht and World War II, this work tries to probe the injustice and horrors of the Holocaust.

In this portrait, I attempt to capture the intrinsic cruel truth of those events.

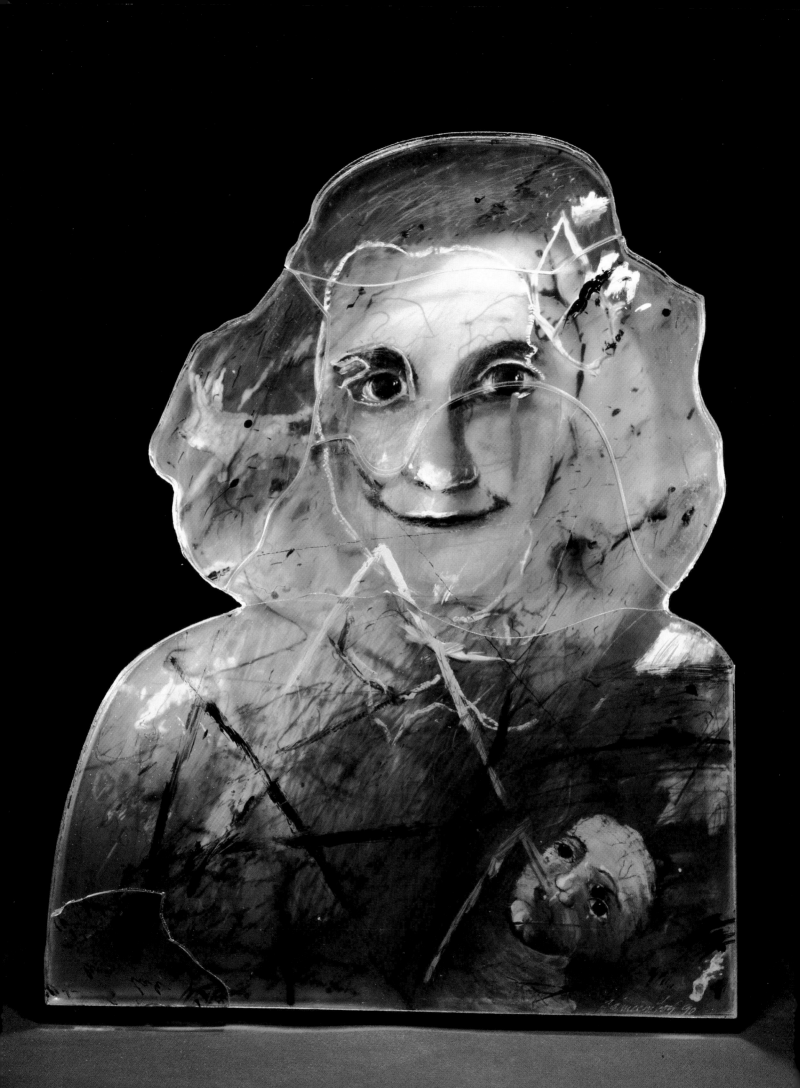

46 **CZESLAW ZUBER**

France

Ritual

21 x 15 x 42″
84 x 60 x 168 cm
Glass block broken with hammer,
sawed with diamond saw, polished,
engraved by sandblasting and painted

GOLD AWARD

The power to rescue,
the power to heal,
the symbol of a spirit that holds fast.

Glass broken, then polished,
glass sawed, then painted.

Ultimately the creation of this work was a ritual for survival.

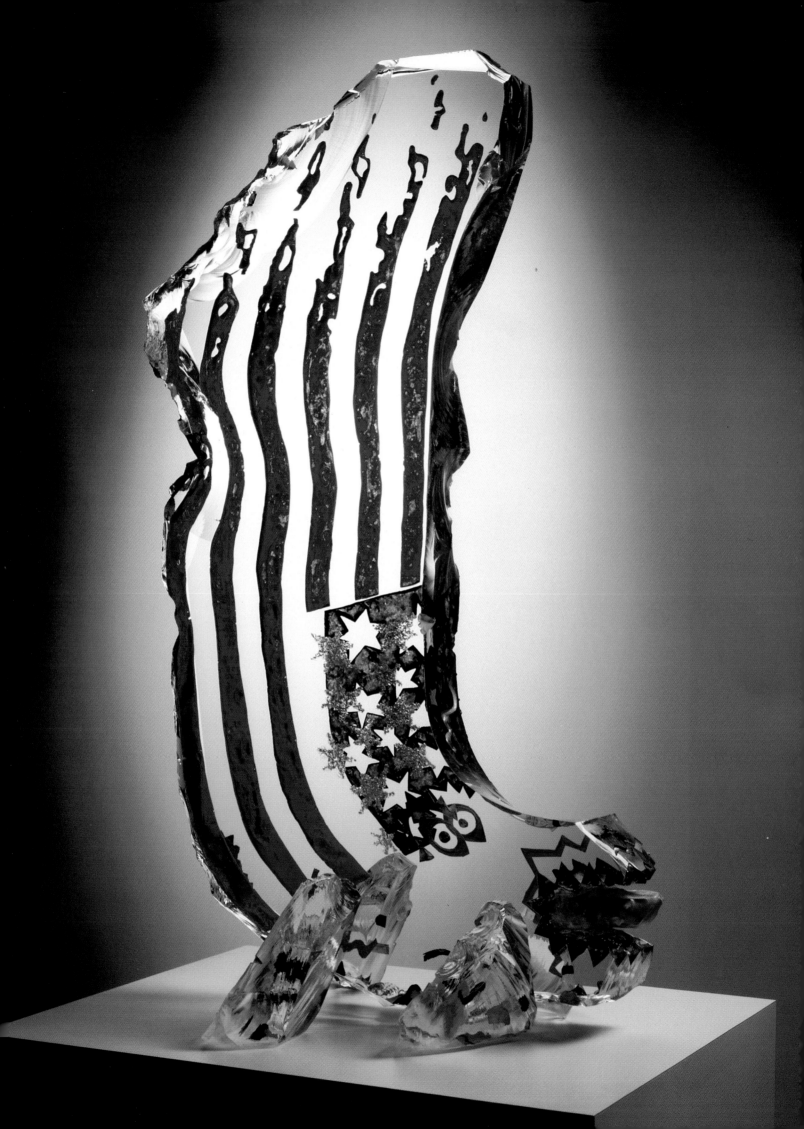

48 **DAN BANCILA**

ᴿᴏᴍᴀɴɪᴀ

Crucifix

17½ x 7¾ x 4″
45 x 20 x 10 cm
Polished crystal

SILVER AWARD

Tʜɪѕ ᴡᴏʀᴋ ɪѕ ᴍʏ ᴘɪᴏᴜѕ ʜᴏᴍᴀɢᴇ ᴛᴏ ᴛʜᴇ ᴍɪʟʟɪᴏɴѕ ᴏꜰ ᴠɪᴄᴛɪᴍѕ of the Nazis in World War II.

The material used, optical crystal, reflects the purity of the martyrs' souls. The space contour of the work suggests the symbol image of Christ. The crystal and the space are forever linked. Together they define the whole. Together they reach for the Heavens.

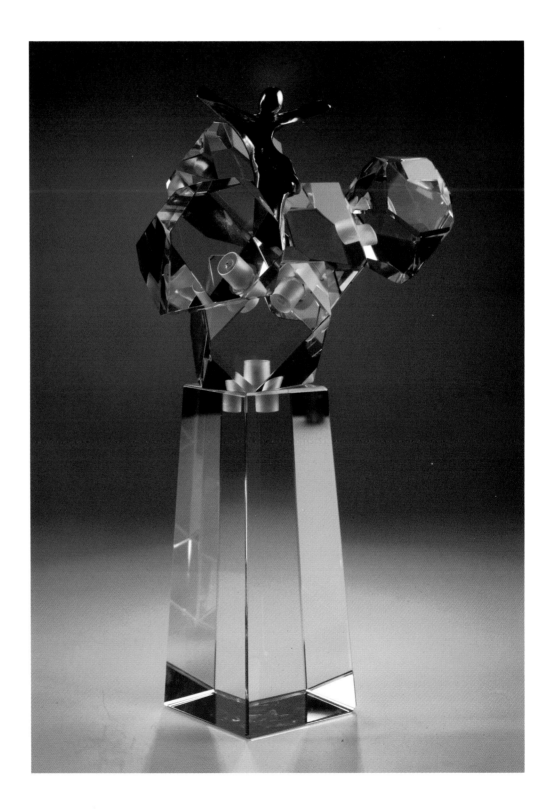

JAN FISAR

<small>CZECHOSLOVAKIA</small>

Memento

23½ x 31 x 27″
66 x 75 x 70 cm
Remelted, reground, painted on
metal pedestal

SILVER AWARD

The feeling of fear goes on.
First fascism and then communism.
I did not get to know anything else.
So, it is not the material nor the technique that is important but the
memento, this souvenir of fear understood and felt and remembered.

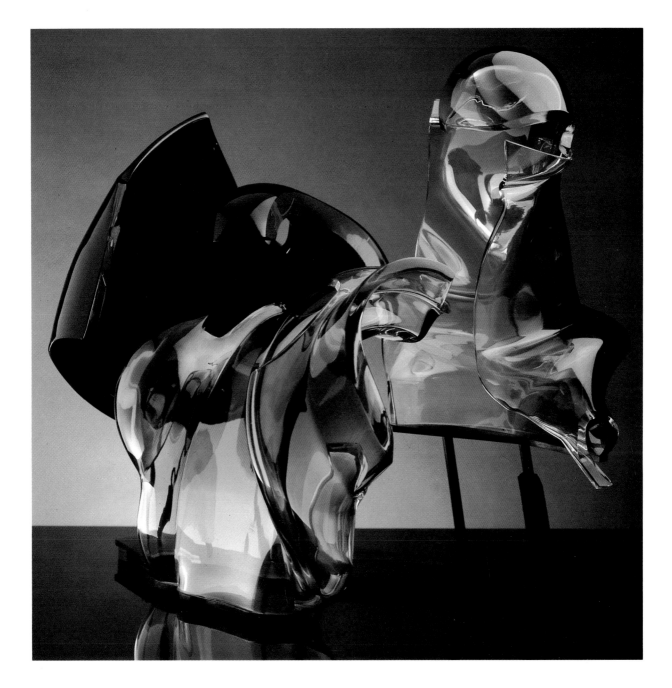

50

HANS GODO FRABEL

<small>UNITED STATES</small>

Holding Fast

29 x 21 x 10¾″
74 x 54 x 27½ cm
Lampwork

SILVER AWARD

GERMANY 1944. VISIONS. NIGHTMARES. DESTRUCTION, violence and death incomprehensible to a small child growing up in Germany.

These are real scenes that have haunted me all these years. In creating this work, I have reflected on my own early experiences in order to understand more fully the horror that war has upon children and the world.

I wanted to find a personal perspective. I sought this by tying the crystal barbed wire into the symbol of those people who bore the brunt of the hate; who held fast to their Star of David. It exemplifies the courage and desperate anguish of a people under genocidal attack.

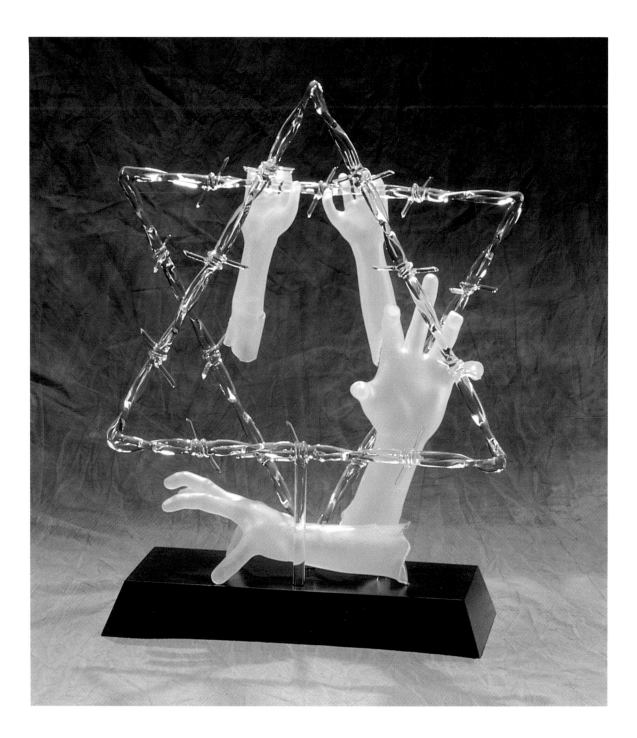

PAM GAZALE

United States

Anne's Diary

7 x 8½ x 2″
17 x 21 x 5 cm
Fused glass, paint and copper

SILVER AWARD

Some years ago I met a man who had a scar on his arm. He told me he had been in a Nazi concentration camp when he was a child and was the only survivor in his family, having lost in addition to both his parents, every relative in the world. He said he had been able to survive via a diet of watered soup and a mock concoction of tea.

In the death camps, individual names were removed from all prisoner records and replaced with a series of numbers that were tattooed on the arm of every man, woman and child . . . just like cattle. His scar was caused by trying to have the numbers removed from his arm, but they could never be completely erased.

That is all he said about it. The hollow pain that filled his soul prevented further explanation.

It took a child, a non-survivor, to add for all time, another dimension to the scope of the Holocaust. It took Anne Frank, in her remarkable diary, to tell the story of a victim who was a beautifully unfolding human being . . . not just another number.

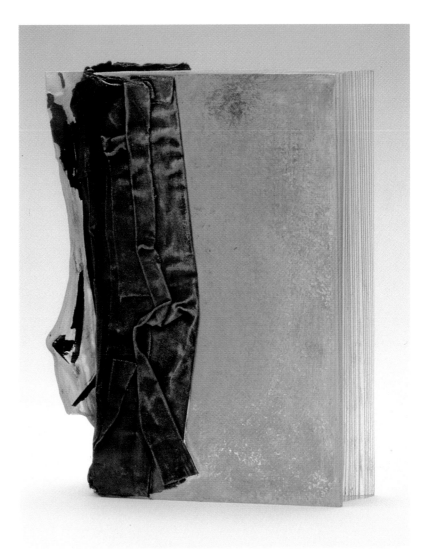

DAVID HOPPER

UNITED STATES

Megalomania

17 X 9 X 3″
44.2 x 23.4 x 7.8 cm
Formed, carved and
painted glass

SILVER AWARD

A LARGE FIGURE IS CASTING DOWN HEADFIRST A SMALLER FIGURE that has the Star of David pinned to its chest. This act of violence addresses the elements of hate and denial that were the foundation of the Hitler era.

Freedom must be fought for every day.
It's all so damned polite.
Even now, they are calling it

"the period of misunderstood violence"

"the grandiose delusions of a nation"

"the curious manipulations of the leader"

They forget to remember that freedom is achieved by looking over your shoulder every day, every season.

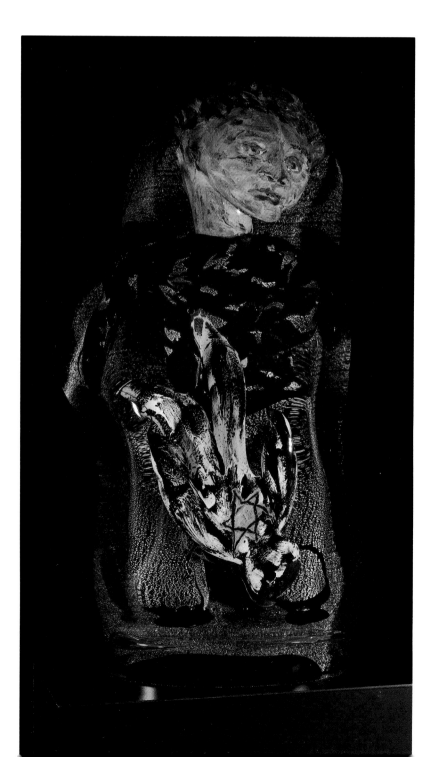

CHRISTOFF KOON

UNITED STATES

The Neighborhood That Knew

22 x 19 x 5½"
57 x 49 x 14 cm
Kiln formed glass, sand cast glass,
blown glass

SILVER AWARD

IN 1985 WHEN I WAS STUDYING ART HISTORY IN EUROPE, the most personally impacting experiences were the times I spent walking through a number of concentration camps. There was one in particular outside of Munich . . . hard to find but worth the searching.

While walking through the courtyards, I came across a large, old ivy-covered wall with a welcoming-looking gate. With curiosity, I opened the gate and saw what appeared to be an old, small groundkeeper's building with an extra large chimney in the back. It seemed quite harmless, until I entered the front door . . . one large room with two doors on each end of the back wall . . .

I entered the left back room. Looking around, all I saw were some old pipes protruding from the walls. Oh, I thought, this bathhouse has a shower room. Through the next door I expected to find the old toilets. When I walked into the next strangely cold room, the reality of the place struck with a force that made me want to vomit. It was all that I could do to keep myself together and not run. The reason and use of the huge smokestack became evident.

After leaving the perimeter of that ivy-covered wall, I turned around and saw on the other side of the compound what looked like a perfectly normal German neighborhood. They had been there all the time. They knew.

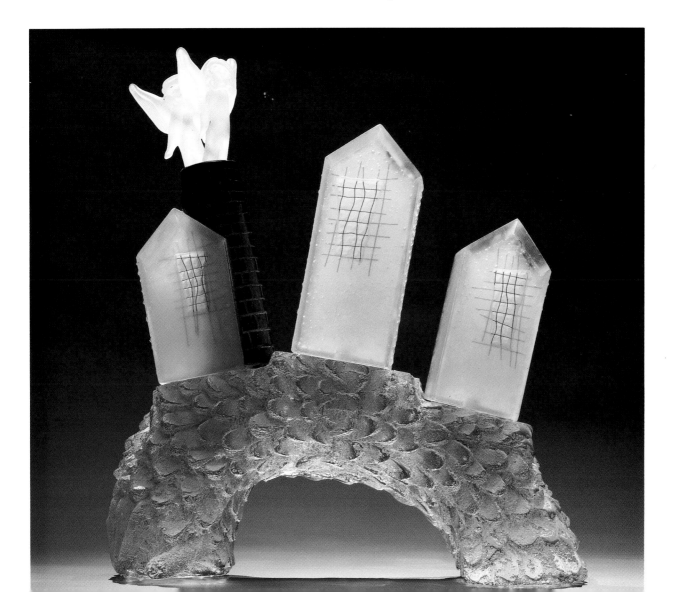

VLADIMIR JELÍNEK

Czechoslovakia

Portrait

7 x 7 x 4″
18 x 18 x 10 cm
Split, cut, engraved
and polished glass

SILVER AWARD

Destruction comes in different phases, different faces. Optics transform a smile into an expression of dread . . . a young girl's face, destroyed by a brutal hit. Just one portrait of Kristallnacht and all that followed.

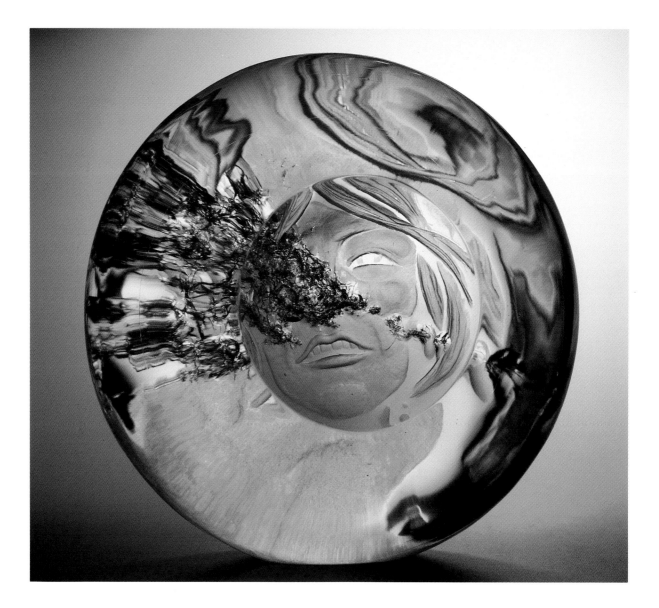

KYOICHI KAMEI

Japan

We Must Not Forget

42 x 15½ x 15½″
104 x 40 x 40 cm
Blown, fused, glued, ceramic steel

SILVER AWARD

*Has so much time gone by
enough time for raindrops to dig a hole in the stones?
All mankind—have you forgotten the grief there?*

The world needs many prayers for the past grief not to recur.

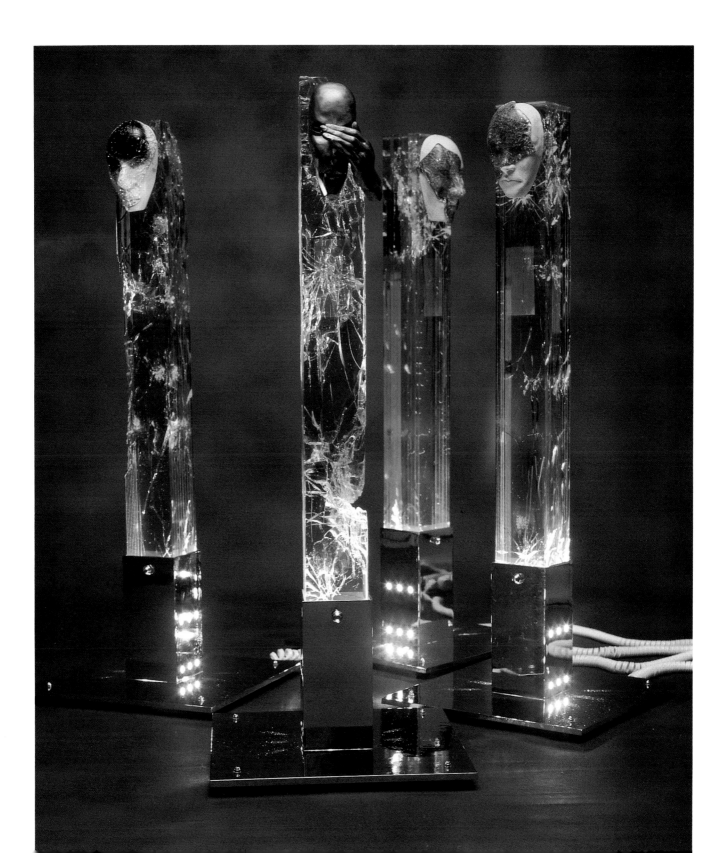

SUZANNE REESE HORVITZ
ROBERT ROESCH

UNITED STATES

Shedding Golden Tears

192 x 156 x 72"
499.2 x 405.6 x 187.2 cm
Glass, gold leaf, enamel towers
and structure of steel/sandblasted
glass, gilded and screened

SILVER AWARD

THIS LARGE WALL OF TWENTY-FIVE GLASS WINDOWS CONTAINS text and images relating to definitions of sorrow.

The work honors and mourns victims of the genocide that erupted during the period of the Holocaust. The bottom plates are mirrored glass pleading with the viewer to become part of the work. The wall cantilevers toward the viewer in an unsettling manner, leaning on towers which represent man's aspiration toward a more perfect existence.

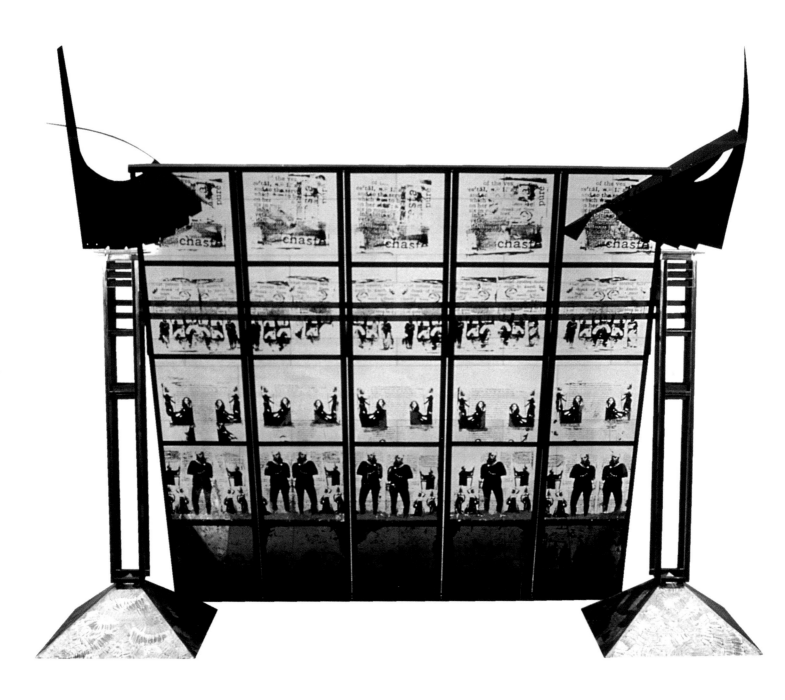

VLADIMIR KLEIN

CZECHOSLOVAKIA

Memory

7 x 7¼ x 7¼"
17 x 18 x 18 cm
Engraved optical glass

SILVER AWARD

I am cloudy,
I am captured pain,
I am anguish,
I am clear as the bell that strikes a warning for the future.

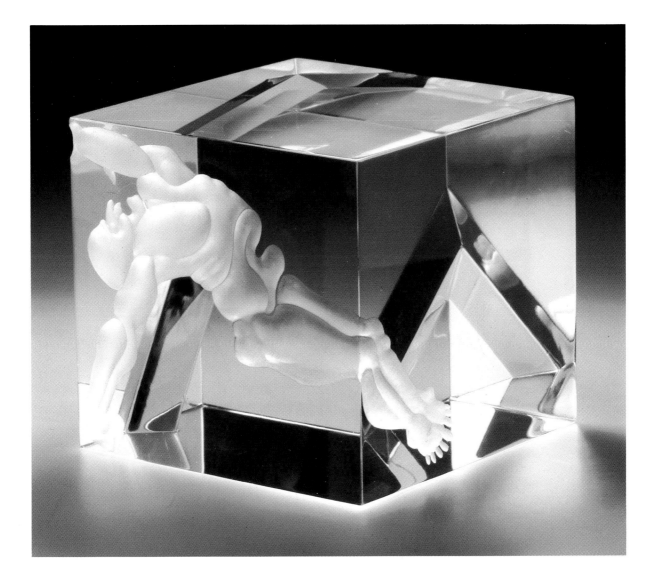

58

THERESE LAHAIE

UNITED STATES

Buoy Woman

26 x 11 x 4"
62 x 52 x 9 cm
Engraved, painted glass,
nautical chart,
mixed media, fiber optics

SILVER AWARD

BUOY WOMAN IS A METAPHOR FOR THE LIFE OF ANNE FRANK. The body is trapped inside of a metal buoy just as her counterpart, Anne Frank, was a captive of the tiny room in which she was hiding. For a period, the room protected her from the threat outside. But, as within any forcibly confined space, all freedom is ultimately denied, all natural growth and movement is hindered.

In this work, a hand reaches toward Buoy Woman, threatening to pull her under. But she does not sink. Her indomitable spirit keeps her head just above water. She breathes, she survives, just as Anne Frank's inspirational words live and inspire us today.

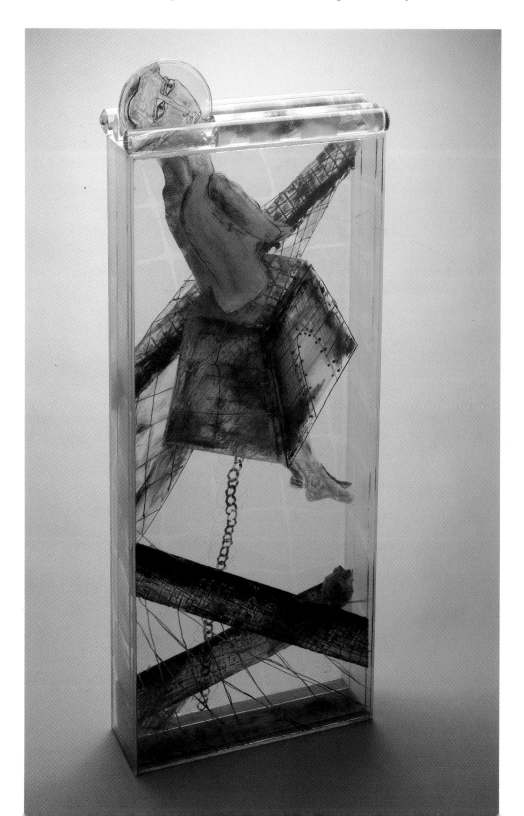

SOREN STAUNSAGER LARSEN

ICELAND

*A Prayer to The Almighty
Who Forgot*

18¾ x 4¾ x 4¾"
47 x 12 x 12 cm
Hot formed, cut, cast glass

SILVER AWARD

THE TRUTH CAN BE OF HORRIBLE DIMENSIONS THAT ARE
impossible to describe, either in words or pictures.

For children in particular, the facts of the Holocaust stay beyond
understanding or simulation.

It is my hope—and at the same time the reason for responding to
the call for entries—that these works will stand as a powerful
manifestation and reminder of the terrible events of Kristallnacht
and beyond. May these efforts, these statements in glass, also
contribute toward a consciousness of those events so the future—
which we ourselves are responsible for creating—will save the
humanity on our earth from similar experiences. I pray for a world
that extends true freedom for everyone, irrespective of race, color,
nationality or religion.

The pillars in my work symbolize the growing of all living things.
The doll head stands for the children who didn't get the opportunity
to grow up. We all share responsibility to the still forgotten child-
ren in the world.

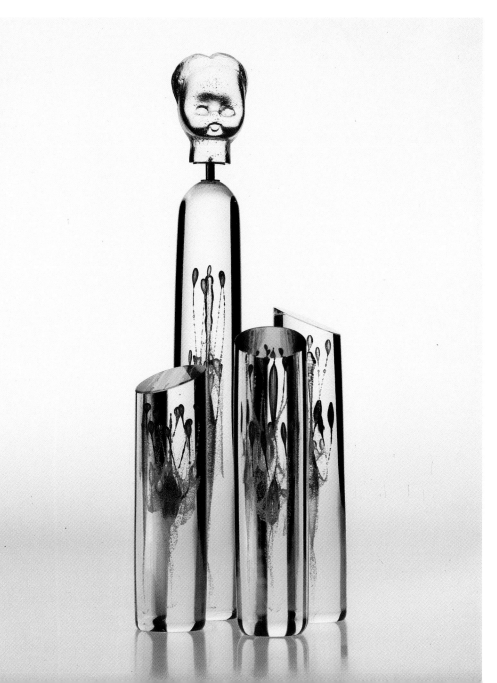

60

PAUL MARIONI

<small>UNITED STATES</small>

Hidden Message

17 x 24″
42 x 62 cm
Leaded glass, slumped glass silicon

SILVER AWARD

<small>THIS LEADED GLASS WINDOW EXPRESSES THE VIOLENCE OF</small> an anonymous attack. The message may be varied such as *"this is a warning"* or *"get out of town,"* but it is always filled with a fearful purpose. In this work, the note attached to the brick is folded inward so that its content is hidden from the viewer just as hate is often hidden . . . just as truth is often denied.

The brick, as it pierces the glass, is three-dimensional to capture the moment of impact.

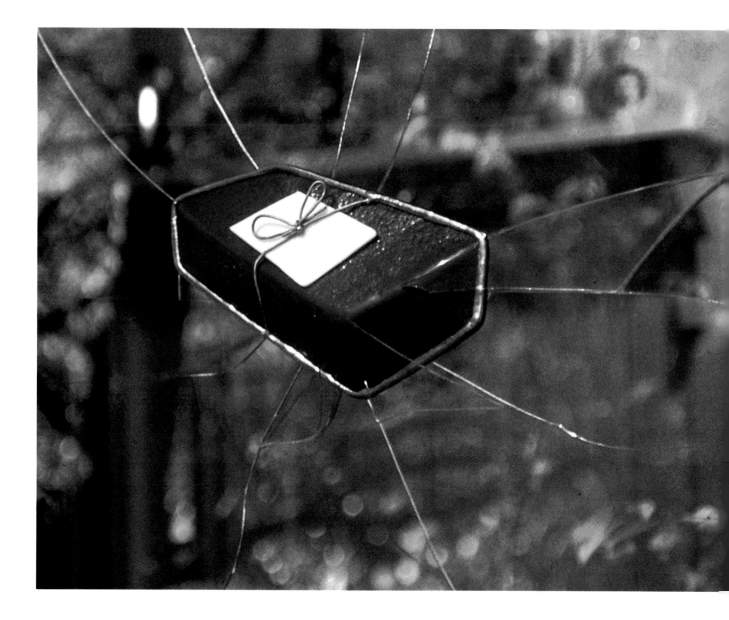

LIZ MARX

UNITED STATES

*Had they seen the writing
on the wall*

5 x 11 x 8″
12 x 28 x 20 cm
Cast lead crystal, lost wax technique

SILVER AWARD

*"No one race, religion, nation or individual
should ever be persecuted, tortured, ridiculed,
shown unjust behavior or oppressive actions.
We are all human beings of the mind, skin and soul."*

My work is suggestive of a prison or cage-like form with written
words upon the walls that enclose the space, that enclose the spirit.

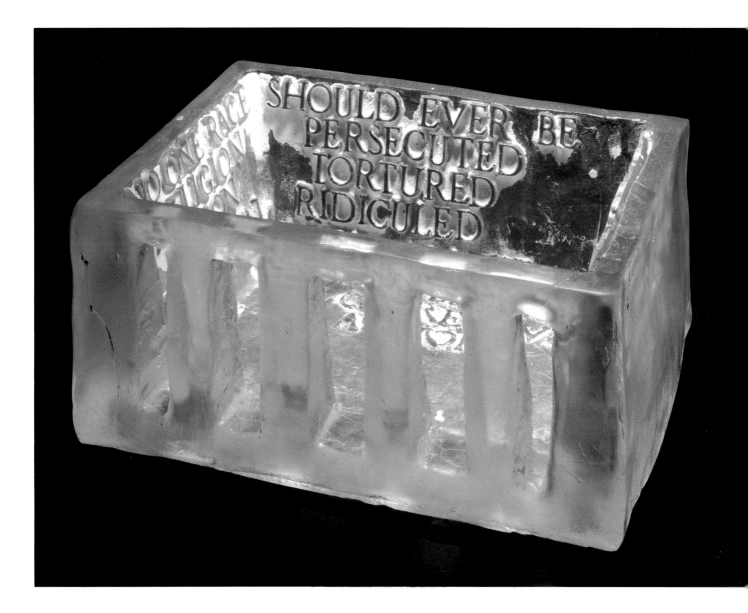

62 **PAVEL MOLNAR**

GERMANY

Viewpoint

9⅞ x 6 x 2¾″
25 x 15 x 7 cm
Solid clear glass,
oven-formed. Inside design
created in front of lamp
with glass rods and tubes.

SILVER AWARD

YES. I WAS WITNESS TO THE HOLOCAUST . . . TO THAT MOST cruel and painful event of human history. I regard it as an act of human duty never to forget.

From my spiritual point of view, I see the Holocaust as a fight of the anti-Christ against God and his chosen people.

It was a satanic fight destined to fail . . . one that, curiously, gave birth to a new hope and vision.

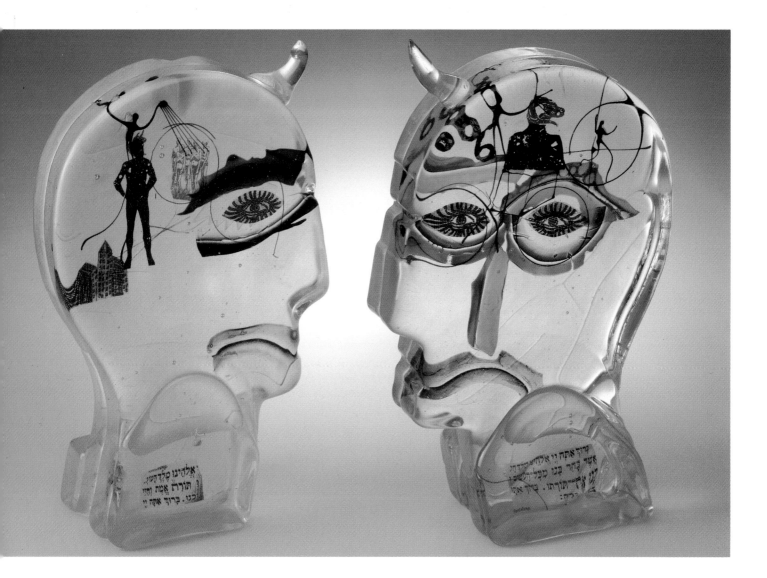

HARTMUT MÜELLER

GERMANY

Herrscher or *Sovereign*

17¾ x 14¾ x 9⅞"
45 x 38 x 25 cm
Flat and clear glass sand blast

SILVER AWARD

We are Germans
and that's reason enough to always remember
Kristallnacht and the Holocaust.

My object is a symbol for the past
and a warning for the future.

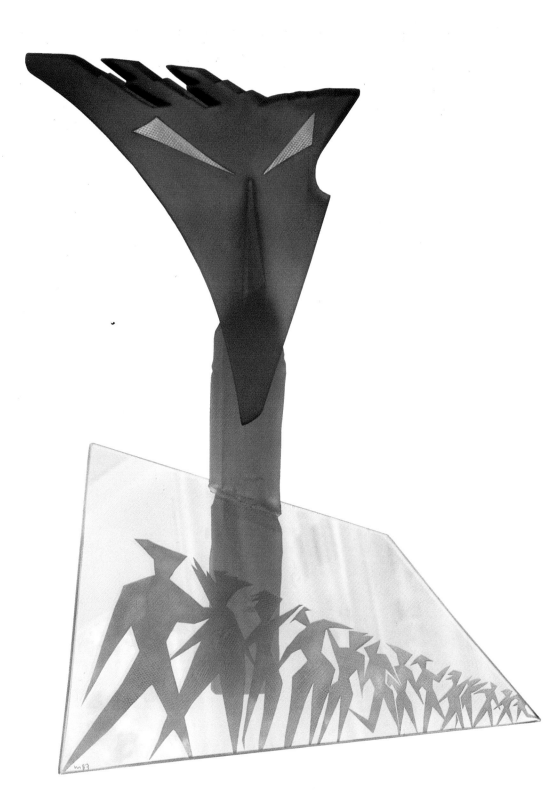

64 **MIRELLA PATRUNO**

ITALY

The Nightmare of Suffering

39 x 41 x ⅝"
100 x 105 x 0.8 cm
Stained glass; painted, fired, treated
with hydrofluoric acid and leaded

SILVER AWARD

THE BARRACKS OF THE CONCENTRATION CAMPS HAUNT ME . . . haunt this work. Like broken glass, the living beings they entombed were raw, shattered fragments of former selves. Meant for five hundred, each block held two thousand. Four or five people slept on every bunk, head to foot. The mattress was filthy straw on wooden planks. Buckets served as toilets. Starvation rations were designed for murder. Prisoners usually did not survive more than six weeks.

If they lived longer, they were executed.

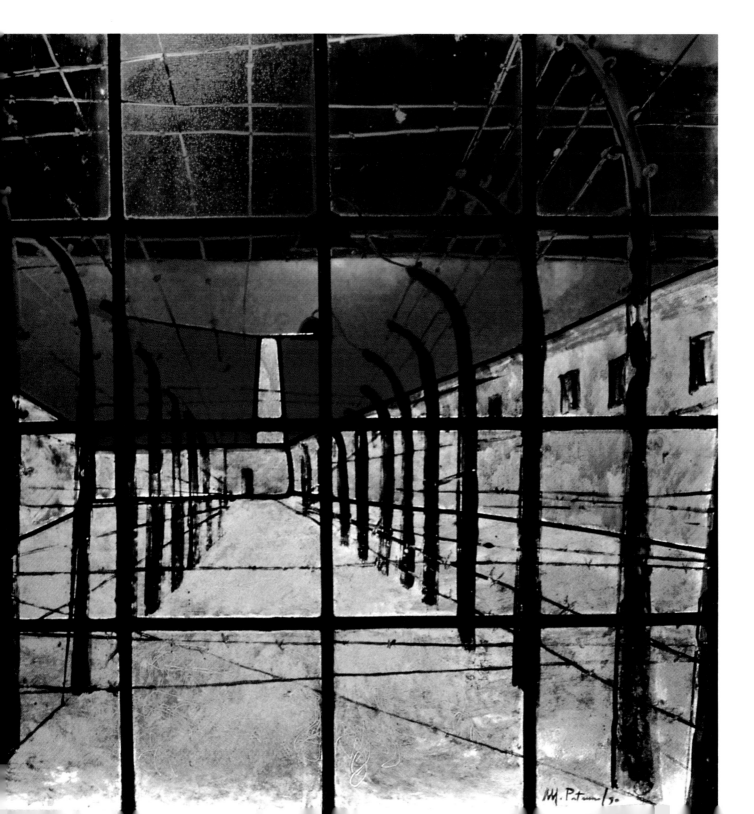

ROBERT PALUSKY

<small>UNITED STATES</small>

Crystal Night

23 x 13 x 7″
59 x 33 x 18 cm
Cast and laminated glass

SILVER AWARD

<small>FOR A NUMBER OF YEARS MY WORK HAS ADDRESSED PREJUDICE.</small> This piece is an immediate and visceral response to Kristallnacht.

I experienced prejudice as a child and as an adult. I understand the hurt it creates in others and the helpless feeling it creates in me, knowing I can do little about it.

I'm not a master speaker nor writer, so the best means I have to express my disgust is through my work.

The Holocaust is more than a symbol. It is a reality. It is a warning. It is a reminder to mankind that ultimate prejudice leads to ultimate destruction of all that civilization holds dear.

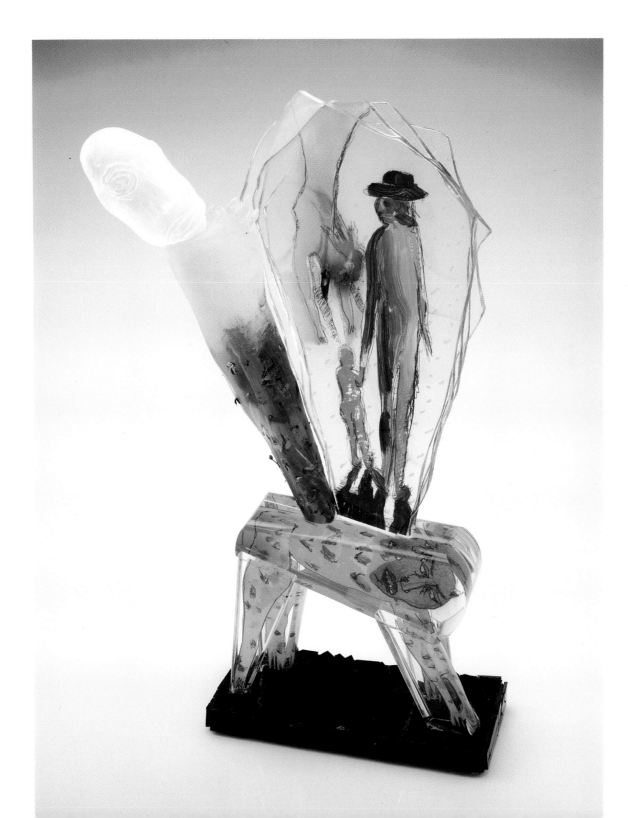

66

STEPHEN SKILLITZI

AUSTRALIA

War Zone

30⅞ x 19¼ x 11¾"
80 x 50 x 30 cm
Lost wax kiln-cast glass
electroformed metals of gold,
nickel, and copper

SILVER AWARD

EACH FACET OF THIS WORK HOLDS PARTICULAR RELEVANCE TO November 9, 1938 and the Holocaust that followed. The two main figures were inspired by my actual visit to Dachau. The smell of death, the horrific images that reside there will never, ever be finished or leave that place. In *War Zone* the earth is depicted as relatively small and precarious. It is a world of arrogance, of self-centered personae surrounded by the fractured glass of Kristallnacht. The entire sculpture is enveloped in a sinister texture and tone and is an allegory for the hideous combination of Nazi persecution and general world indifference. I acknowledge the sickening reality of a civilization that permits such horrors to exist . . . *and I weep!*

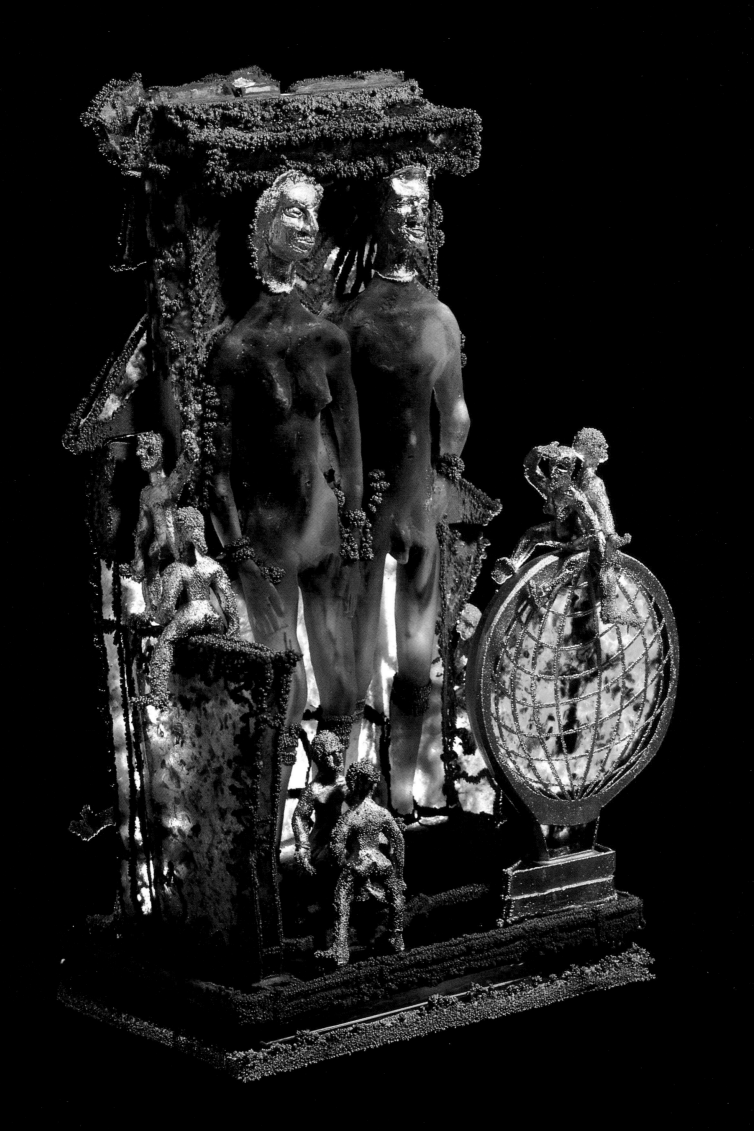

SIBYLLE PERETTI

GERMANY

Open Wounds

6⅝ x 3⅛″
16 x 8 cm
Mould blown, sawed, engraved,
enameled, lustered glass and rusty wire

SILVER AWARD

OPEN WOUNDS THAT CAN NEVER HEAL . . . THAT STILL ooze with memories of brutality and pain, of ravages and death.

Nothing can describe the Holocaust that was thrust upon us by the Third Reich. We must guard against hushing the grief and the horror. We must guard against placating citizens who were involved. We must guard against apathetic notice followed by a return to business as usual.

That is what this memorial is all about.

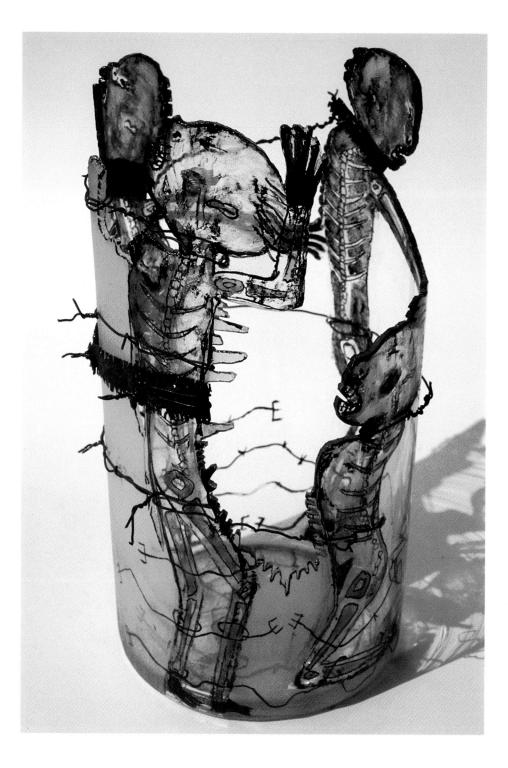

FRANK ROOT

UNITED STATES

Street Scene: An equation

21 x 23 x 5″
84 x 92 x 20 cm
Glass, homosote and black pastels

SILVER AWARD

I HAVE TRIED TO IMAGINE 6,000,000 JEWISH CITIZENS MUR-dered: children, mothers, fathers, grandparents . . . whole families extinguished. I have tried to imagine my own dear ones systemati-cally and brutally put to death. The equation is impossible, too much to conceive. I can only bring it down to this work . . . a street scene after Kristallnacht, where the culture and traditions of a people lay shattered, the result of a hate that is, after all is said and done, still being taught, still being manufactured.

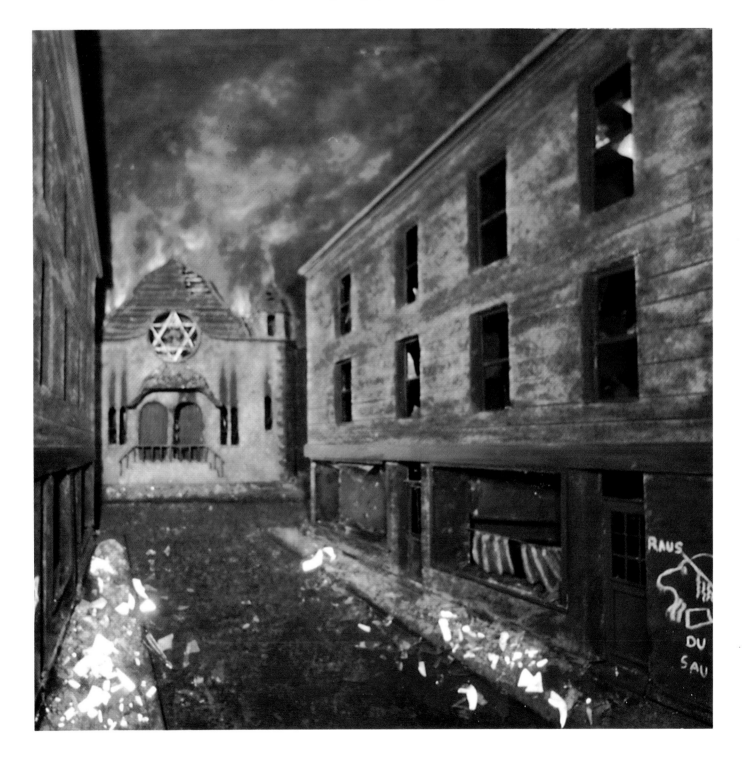

SEM SCHANZER

Belgium

They Were a Family of Eight

13 x 9 x 13"
33 x 22.8 x 33 cm
Cast glass and wire

SILVER AWARD

Ahek Schanzer, Poland 1942.
Eight bullets in his body and still standing.
Civilian, powerless and unarmed in front of his armed murderer.
The ninth bullet to his head ended his life.

Avraham Schanzer, murdered the day of Yom Kippur 1943.
Caroline Schanzer, murdered September 3, 1943.
Ida Schanzer, murdered September 23, 1943.
Ignas Schanzer, murdered September 23, 1943.
Yoshua Schanzer, murdered September 23, 1943.
Their crime: to be born a Jew. Killed, murdered.

THEY WERE A FAMILY OF EIGHT. TWO SURVIVED, ENDING the war as resisters, weighing only 30 kilos but alive and having preserved their cultural and religious identity.

Only two survived, a reminder of the millions of Jews and the disabled and the opponents of the regime who were exploited and exterminated in inhuman conditions, tortured, gassed and burned. Only two survived, a footnote to genocide that killed communities and cultures in Europe that were over a thousand years old.

Exterminated by madness, by a thirst for power, by the indifference and silent complicity of others.

My work is a call for—a shout for—the transmission of information to the public, to schools and universities. In order to avoid a new killing madness. In order to watch for symptoms to reappear. In order to be able to stop it at once. In order to never again permit this inhuman madness to occur.

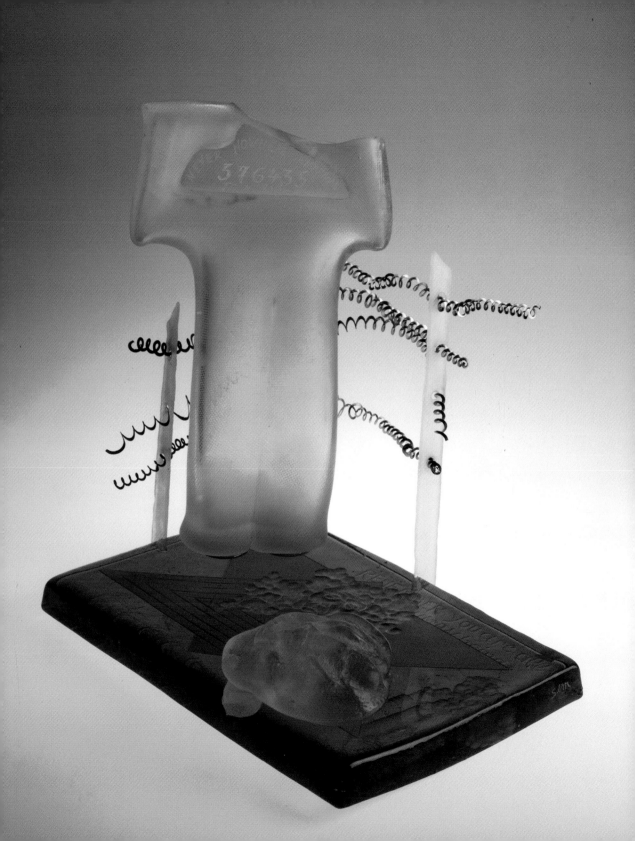

DAVID RUTH

UNITED STATES

*River of Remembrance
—O Merciful Lord*

32 x 14 x 6″
81 x 36 x 15 cm
Cast glass, stones from the Mad
River of Northern California

SILVER AWARD

THIS WORK TAKES ITS NAME FROM THE JEWISH PRAYER FOR THE dead. Embedded in the glass are but the most minute remains of any imagery. The lives of more than six million victims were destroyed in the Holocaust. Only their ghosts and our remembrance remain. Each of these people had their life's fulfillment denied. The enormity of this sin flies in the face of God and scars us all forever.

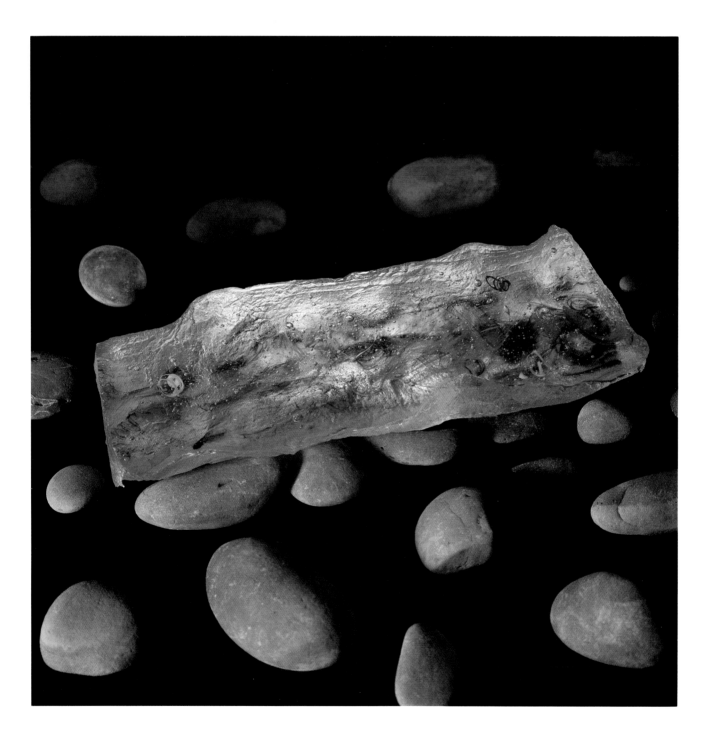

MARY SHAFFER

UNITED STATES

Untitled

16 x 12 x 7″
41.6 x 31.2 x 18.2 cm
Glass and copper

SILVER AWARD

EVERY SOUL THAT WAS ALIVE DURING THE HOLOCAUST IS PART of it—part shame, part victim.

I do not believe in transmigration, but if I did, I would know I wasn't an Egyptian princess. I was a child of the Holocaust.

When I walked into a shower room of a *lager* in Czechoslovakia, my left side immediately froze in unbelievable, intense fear as if I had been given a death blow.

I cannot explain. I cannot explain the scope of my feelings, the depth of my sadness. I do not have the words. I am an artist. I make work that is a spirit set free by a furnace.

73

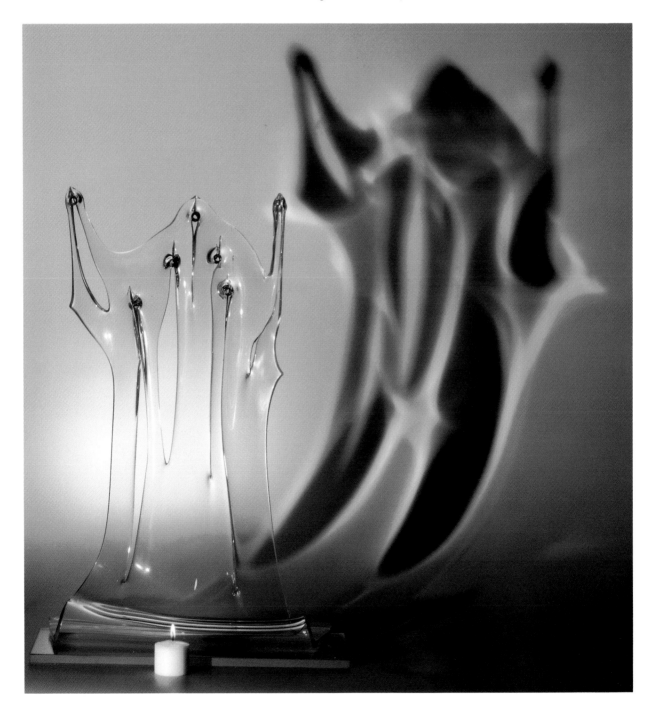

74

STEVEN TATAR

United States

Sanctuary

19 x 15 x 7"
49 x 39 x 18 cm
Fused window glass; enamels,
stone, brick

SILVER AWARD

Rembrance is an act of healing. If we forget, we risk becoming what we fear. The pain cannot be ignored or it will subvert us. We commemorate this tragedy to acknowledge our loss and to celebrate our rebirth.

From the shattered shards of glass and broken paving stones, we make our sanctuaries, where from within, the image of ourself gives light and renewal.

This sculpture is made from pieces of broken window glass, fused together by the heat of the fire, and mounted on building stone and brick.

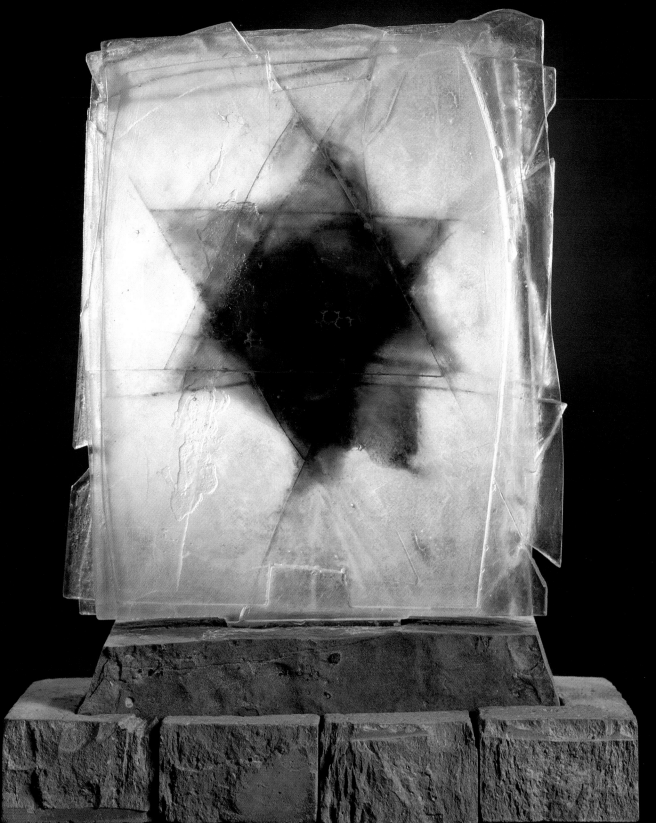

THOMAS TISCH

Austria / United States

Shadow in a Museum

24 x 18″
62 x 49 cm
Glass, metal and light

SILVER AWARD

The Nazis used a gutted synagogue in Prague as a ware-house to store Torahs and prayer books removed from Jewish houses of worship.

Hitler announced that he would create his own museum of an extinct people . . . a satanic, chilling plan that almost succeeded.

In this work, the formalistic shape of the glass resembles the Tablets of Law brought down by Moses from Mt. Sinai. I made them look like they have been through hell. And really, haven't they? Still, they have been preserved and mended. Their presence reminds us of what was. They are not extinct. They live.

Light is projected through the glass to create a shadow image. It is not static just as life is not.

God's law was almost annihilated by the Nazis, but let us not forget they failed. Let us never forget. Resurrected, the Law casts its light, ever changing, always elusive, always a mystery to humans. The shadow is what we see.

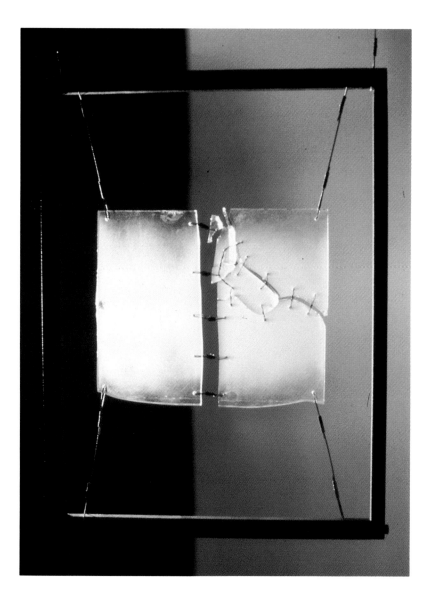

MIHAI TOPESCU

ROMANIA

Heilige Night

6¹¹⁄₁₆ x 9⅞ x 9⅞″
17 x 25 x 25 cm
Cast and polished optic
glass and metal

SILVER AWARD

Destruction and reconstruction,
blind hate and all-seeing love,
fall and flight.

My Christ-like figure is enveloped in pyramids of glass, just as the Jews were caught in a pyramid of hatred built by Hitler, the modern-day Herod who again crucified children of God, who denied the potential for the divine in man and unleashed that which is most base.

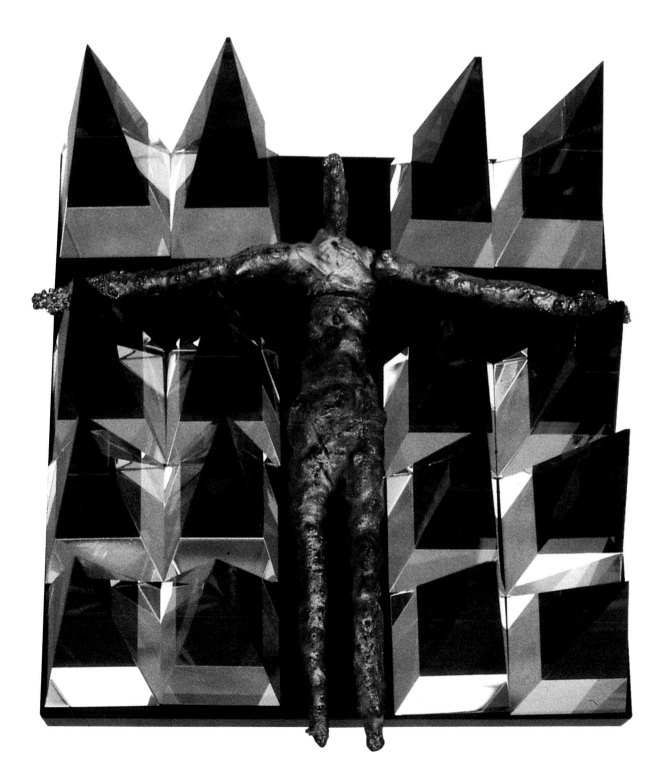

DANA VACHTOVA

CZECHOSLOVAKIA

Fade Out Homes

15½ x 21¾ x 13⅞″
40 x 49 x 30 cm
Cast glass

SILVER AWARD

THIS WORK WAS SHAPED BY SEVERAL EVENTS, SEVERAL PERceptions. In the Autumn of 1988 I was at last able to go and see my brother who had emigrated to Germany. On November 9 I happened to watch a documentary film made for the anniversary of Kristallnacht. Once again, I listened to that merciless litany of figures and facts. However, what really shook me to the depths of my soul was not the repeated realization of what had happened in the past, but the absolute indifference of the present towards that past.

I could not comprehend that fifty years after this event, which stood at the beginning of inconceivable tragedy and crime, the synagogues of Hessen still stand in staring, silent shock over that time of fifty years ago. They are uncomfortable witnesses from whom people turn their eyes away; skeletons wherein only the winds turn the leaves of decaying books and swirling papers listing the names of people long since dead. Next day I went out to see for myself. Hidden away as if outside all time, are these synagogues with broken windows, half-burnt rafters, collapsed roofs, piles of rubble and splinters. Nobody remembers anything, nor do they try to explain.

And now the paradox to the situation. I recall when we were children and had to flee in 1938 with our parents from the small town in north Bohemia when the region was occupied by the Germans. My brother emigrated to Germany after the Russian occupation of Czechoslovakia.

And another paradox—like it or not, I have to remind myself of how several years after the Germans were moved out, I vainly tried to find our village in that same border region of Bohemia. All I found in place of the village were the church steps and an avenue of trees.

It was then that I realized that the violence and despotism of "final solutions" have similar characteristics, and that we find their traces in many shattering connections that cruelly afflict powerless people. In my work I used to be excited by the incessantly overlapping elements of nature, their end and ever new beginnings. Now it is the phenomenon of evil, human indifference and aggression, ever disrupting the likeness of our world. *Fade Out Homes* is my trail of perceptions, reflections and findings on this subject.

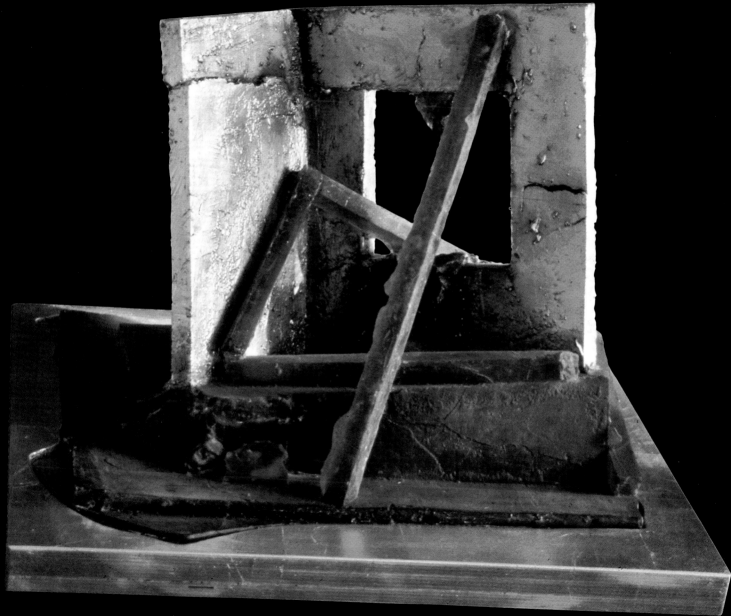

LYNNE-RACHEL ALTMAN

Sweden

Connections

16 x 10 x 7¼"
40 x 25 x 18 cm
Blown, sandblasted and engraved
crystal with shards and wire

BRONZE AWARD

At first I had wanted to make a personal memorial to a spirit who had perished in the Holocaust. When I began, I considered not just the Jewish experience of the Holocaust, but in a larger sense, the psychology surrounding violence and persecution.

What emerged were two faces connected by the relationship between hatred and pain. The side expressing pain has its eye open in terror and its mouth screams as a result of the abuse experienced. The other side, full of hatred and anger, is blind and deaf to the suffering it causes. It is impossible to view one side without the other.

Their minds are pierced and wired together. If one looks inside, it is possible to see the concepts of "guilty" and "innocent," "victim" and "abuser," "self" and "other," and "in here" and "over there". . . . not separate, but dangling as distorted and fragile sides of the same experience.

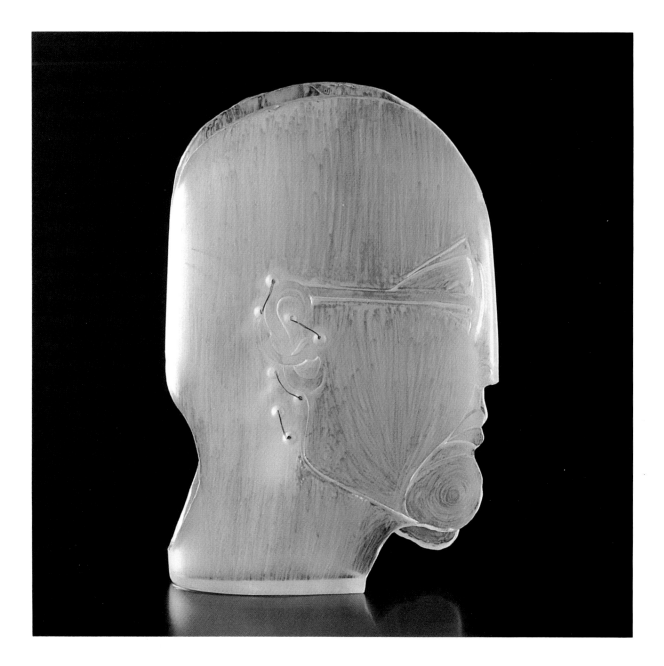

MICHAEL ASCHENBRENNER

<small>UNITED STATES</small>

Mengele

9 x 4″
23 x 10 cm
Solid glass bone in water jar

BRONZE AWARD

AS AN ARTIST, I AM A WITNESS OF TIME. ARTISTS ARE RE-flections of society, its mirrors. It took Ernest Hemingway twelve years after World War I before he could write about it. I, too, was involved in a war. It took me about the same amount of time to understand what happened to me. While serving, I began to perceive things in a significantly different manner. The reality of death opened new avenues of thought for me. Certainly, my experiences from a leg injury in an Army hospital have added to the imagery in my work.

During the early development of this series, images appeared and reappeared to form a language of symbols. The image is of strength and fragility. It is somehow chilling. One is confronted by an ambiguous perception: the skeletal association of death and the essence and structure of life.

My work is about situations, circumstances, conditions and environments affecting the individual. Specifically, this work relates to the unspeakable experiments of the infamous Dr. Mengele.

From a technical point of view, my work is quite simple. It does not attempt to flatter the view. There is no reliance on technique for its own sake.

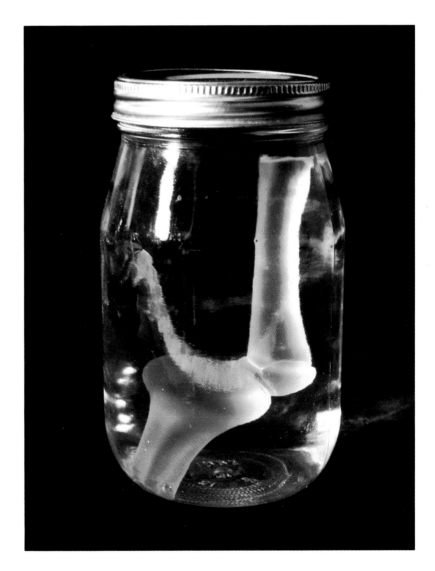

GILA BAR-TAL

Israel

Children's Death March

13½ x 8 x 7½"
41.1 x 20.8 x 19.5 cm
Fused glass pieces, textured and
enameled on glass base

BRONZE AWARD

I WAS THERE, AND I HAVE SEEN THE UNBELIEVABLE: CHILDREN, marching to their death. For tens of years I could not think about depicting it. This was a non-subject . . . untouchable. When it erupted, it was in glass. Generally, I do not use glass as a sculptural medium. Was it an unconscious feeling, that the work had to be expressed in glass, because everything began with smashed glass on the Kristallnacht? Maybe.

I had to struggle not only with the subject and my own inner resistance, but with the material as well. Glass does not yield to the sculptor's will, as does clay, stone or wood. It can be shaped only in the molten state. Ultimately, it is time, anxiety, urgency and the subject itself which has created and permeated the whole essence of this work.

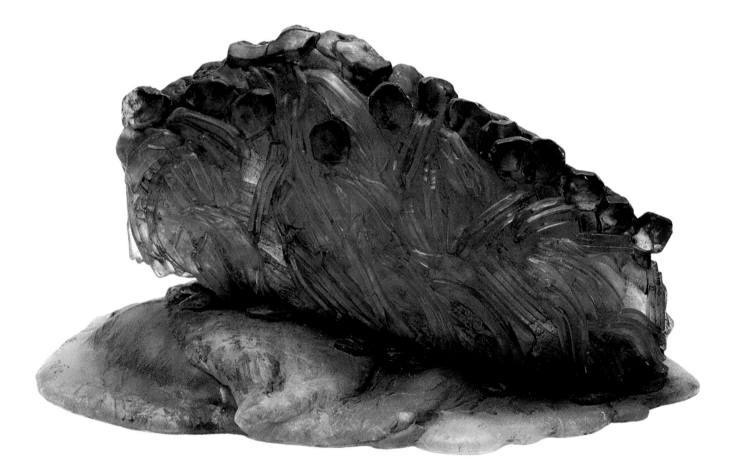

JOHN BOLLE/JOHN CAYS

UNITED STATES

Kristallnacht

31 X 22 X 22"
80.6 x 57.2 x 57.2 cm
Blown and fused glass
on wooden base

BRONZE AWARD

THE KRISTALLNACHT: MASS ARRESTS THROUGHOUT GERMANY.
The Crime: having a Jewish mother or grandmother.
Would they have also arrested Jesus and John the Baptist?

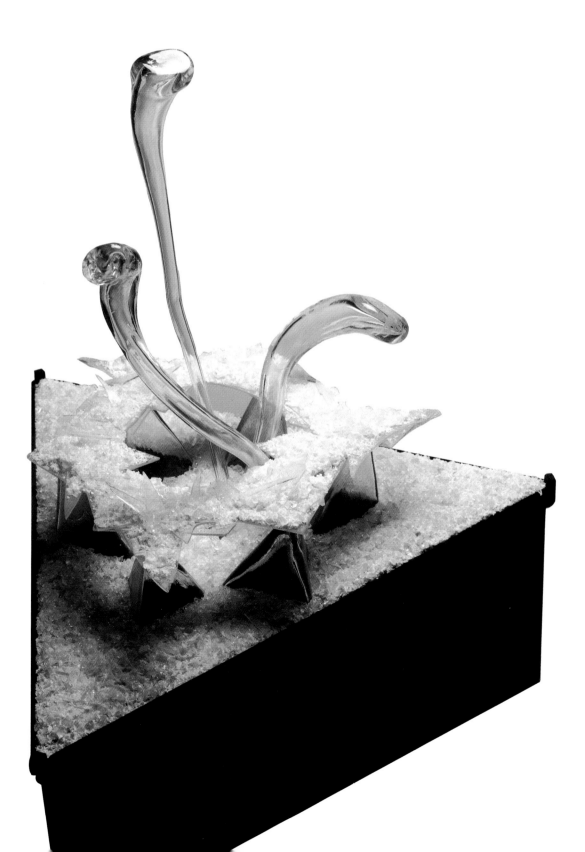

84 **GERHARD F. BAUT**

UNITED STATES

*Life Offering: The Sacrifice
of Maximillian Kolbe*

78 x 42"
202 x 109.2 cm
Structural stained glass, milled
aluminum, mouth-blown flat glass
laminate, aluminum extrusion

BRONZE AWARD

THIS WORK COMMEMORATES THE LIFE AND DEATH OF MAXI-
millian Kolbe at the hands of the Nazi regime at Auschwitz. Father
Kolbe offered his life in place of another man who was the father of
two sons. During the execution ordeal by starvation, Father Kolbe
led his fellow prisoners in prayer. As the last survivor, he was
executed with a lethal injection of carbolic acid.

I have portrayed this Polish Franciscan recently canonized by the
Roman Catholic Church in prison garb next to the man he spared,
who is depicted as an icon of Christ with a shorn head.

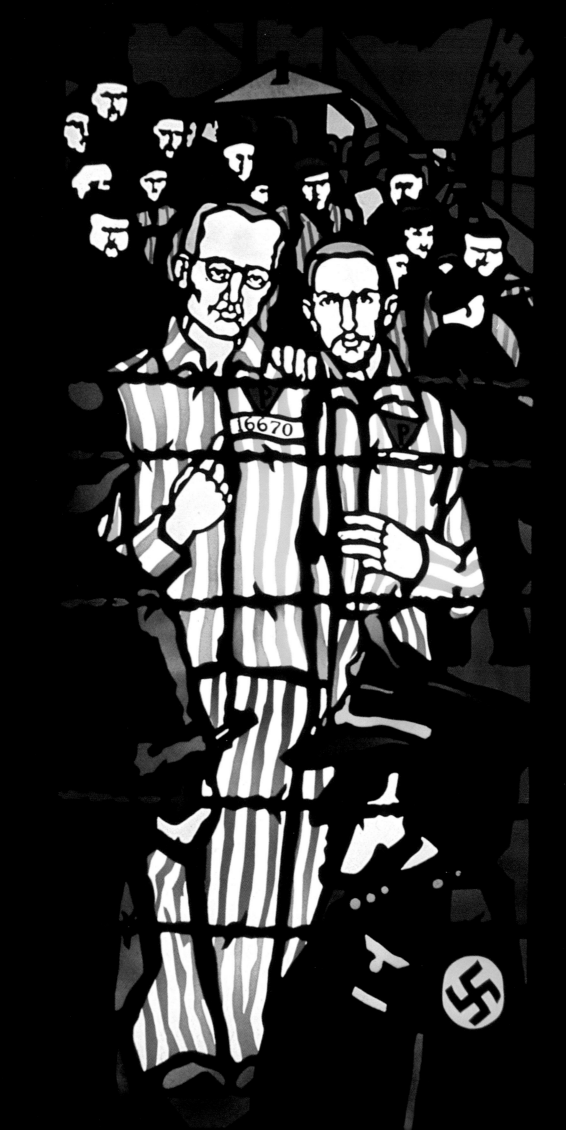

ANDI BILAND

<small>SWITZERLAND</small>

*Concentration Camp
No Way Out*

11 x 12"
28 x 30 cm
Free blown colored glass in
combination with iron and light.

BRONZE AWARD

FEEL IT, IF YOU CAN . . . THE HOPELESSNESS OF INNOCENT people in a prison, surrounded by barbed wire. There is no way out.

I want to recall the sinister world of the concentration camps. The people imprisoned become as objects—scarcely alive. All that remains of those who seek escape are some red stains—their blood.

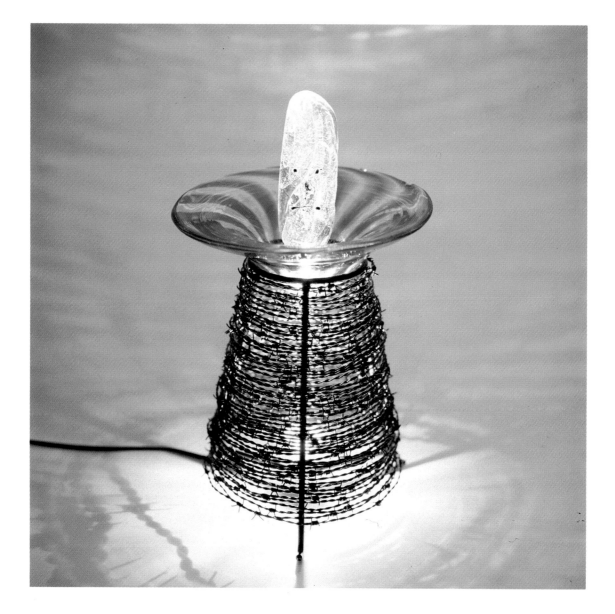

BETH BLIK

ENGLAND

Now is Then
 Then Is Now

26½ x 19 x 19"
68 x 49 x 49 cm
Hot glass figure, kiln formed
base, rods and flat glass

BRONZE AWARD

FROM THE PAIN AND RAVAGES OF THE HOLOCAUST NEW LIFE grows. It is, however, eternally bound to what has gone before, coloring the lives of all children in futures still to come.

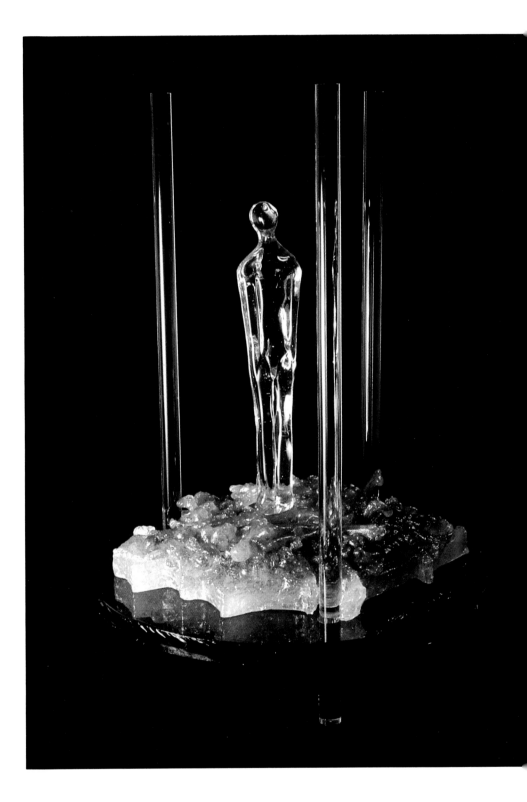

88

**GILAT BLECHER
RONEN KANDEL**

Israel

Remnants from the Attic

19⅞ x 22¼ x 25¾″
50.5 x 56 x 65 cm
Sand blasted glass panel ⅜″ thick
painted, lampworking and mixed media

BRONZE AWARD

This work is a memorial to the despair, fear and lone-liness felt by Anne Frank and her fellow fugitives during the long, long period they spent hiding in the attic.

These eight persons entered into seclusion from the outer world in hope. They left the attic in total terror of the atrocities which were to be their fate.

This is a cry—no, a scream—for the hollow remnants of the past which is no more . . . a past we hardly dare remember.

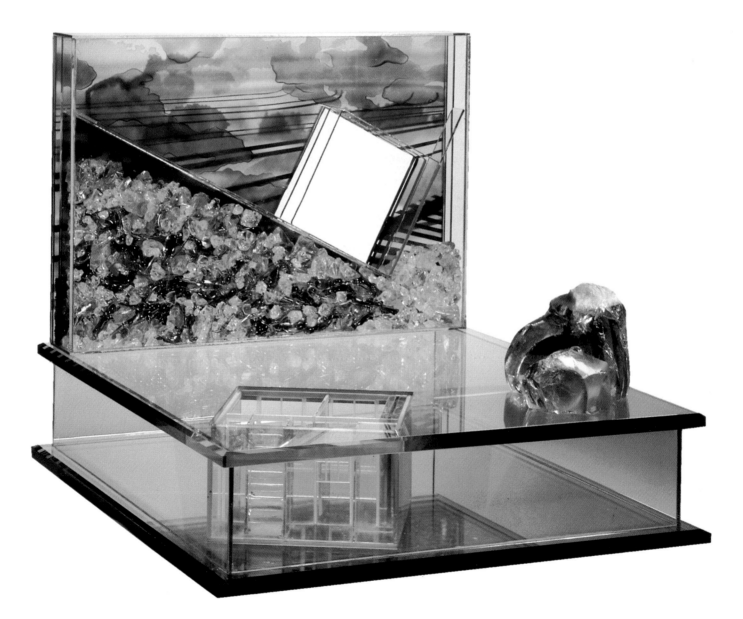

KATHY BUDD

<small>UNITED STATES</small>

Mechanically Inclined

17 x 16 x 5″
44.2 x 41.6 x 13 cm
Slump cast glass and welded steel

BRONZE AWARD

As a person of Polish descent, I felt a desire to understand and come to terms with these historical events. This work is my personal reaction, my understanding of the events of Kristallnacht and the Holocaust.

My expression of anger, disbelief and bitterness is directed at the people who so blindly and mechanically killed and allowed the killing of fellow humans by following a government that judged and murdered according to heritage.

Mechanically Inclined is a visual statement on the Holocaust that followed Kristallnacht . . . a continuing horror, run like a machine by the Nazi government, that bound its own people to a mechanical existence.

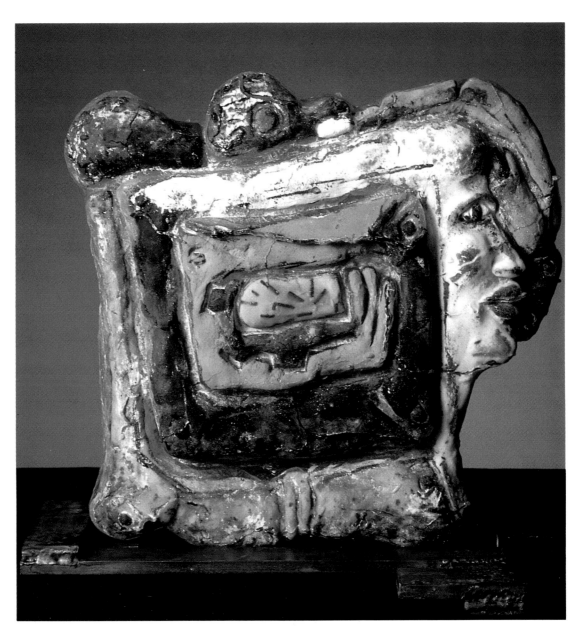

MARK CESARK

<small>UNITED STATES</small>

Window Pain

27 x 22 x 1½"
119 x 101 x 3.8 cm
Glass photo in wood frame

BRONZE AWARD

IMAGES THROUGH CRACKED PANES OF GLASS . . . REFLECTIONS of fear, oppression, suffering . . . the hideous massacre of millions of innocent beings.

The broken glass portrays the hate-filled force of Kristallnacht and its violence. This was the beginning of an inconceivable era when humankind became mere grey shadows in their spaces of terror.

The shattering of the glass is structured and symbolizes the controlled destruction of those who suffered.

My hope is that all who view this work will come away determined that such an abomination will *never* again be permitted.

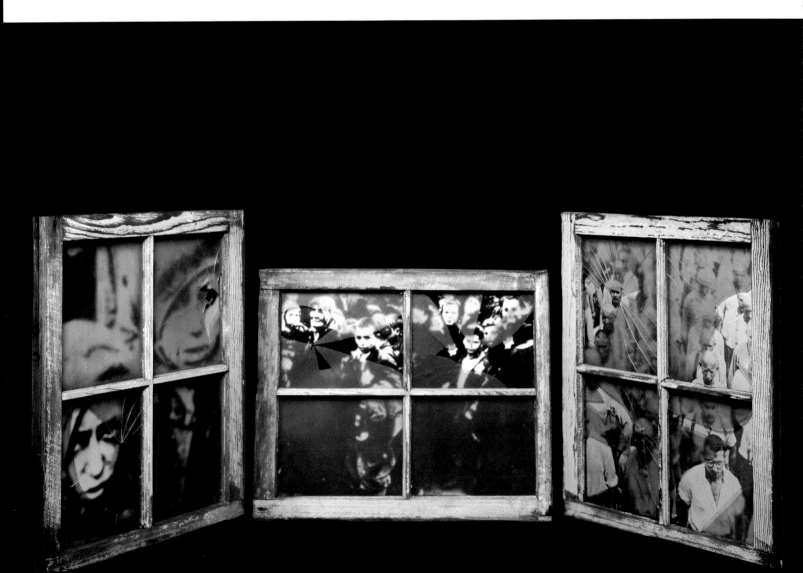

SAMMI FRASER

UNITED STATES

Innocence Betrayed

12½ x 13½ x 16½"
32 x 35 x 43 cm
Slumped and laminated glass
utilizing glass holograms
for illustration

BRONZE AWARD

THE ATROCITIES PERPETRATED ON CHILDREN DURING HITLER'S reign of terror are so overwhelmingly frightening they defy description. Even more fearful is the fact that it continues in this decade. In every corner of this world, small children are trampled as if they were but underbrush, things that don't matter, mere saplings in a forest to be cleared out of the way like some sort of human trash.

It was difficult to express my feelings. I incorporated clear glass and holograms with a shattered crucifix and Star of David to produce an image of denial . . . an image of all that these children would never become.

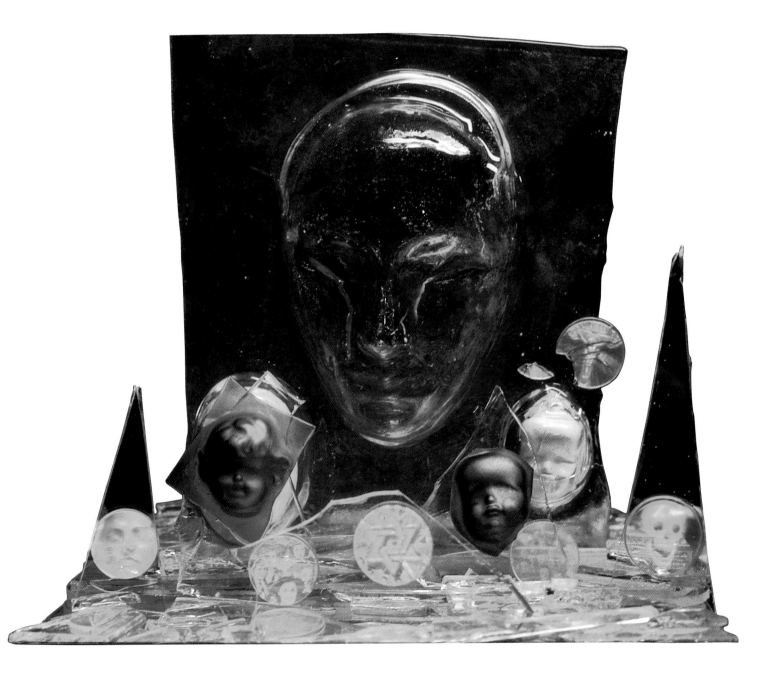

HANS-JOACHIM GERICK

GERMANY

Konzentrations-Lager

14 x 32 x 44"
35 x 80 x 110 cm
Glass and wood

BRONZE AWARD

BLACK PANE OF GLASS FOR MOURNING

Twelve fenceposts for each month of the year. The Holocaust lasted seven years.

The fence for the perfect machinery of death . . . twice as high as the mirror house which made escape impossible.

The "H" on the roof of the mirror house for Hitler, Holocaust, Hell.

House/gas chamber for the death that was waiting for the Jews who were sent inside and told that they would just be taking a shower.

The mirror for looking into. Ask yourself, "Would I have closed my eyes to the truth of what was really happening or would I have been one of the few people that would have fought against the dictatorship?"

Skekurit-pebbles/broken crystal mirror glass for the millions of victims . . . each pebble a reminder.

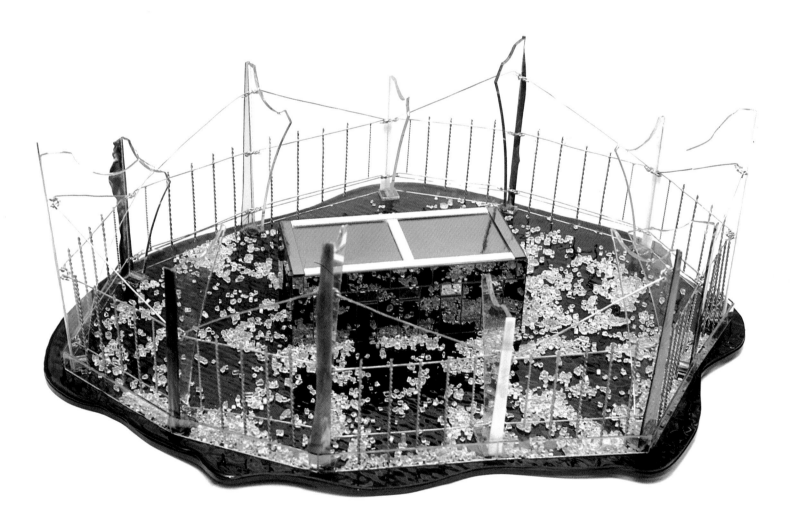

LINDA GISSEN

<small>UNITED STATES</small>

Kristallnacht Yahrzeit

6 x 8 x 7"

15 x 21 x 8 cm

Kiln fused, enameled and slumped glass—engraved bronze and copper direct welded metals

BRONZE AWARD

THIS YAHRZEIT (MEMORIAL) SCULPTURE INCORPORATES PIECES of glass as a central element and theme. Intertwined in the shards are engraved memories of lost loved ones, barbed wire and an admonition: "Zachor" "Remember."

The bronze figures behind the barbed wire and the smoke images enameled onto the glass address the reality of Kristallnacht and the inconceivable horrors that followed. The Yahrzeit candle, which Jews traditionally light on the anniversary of a loved one's death, is lit to remember and memorialize the Kristallnacht.

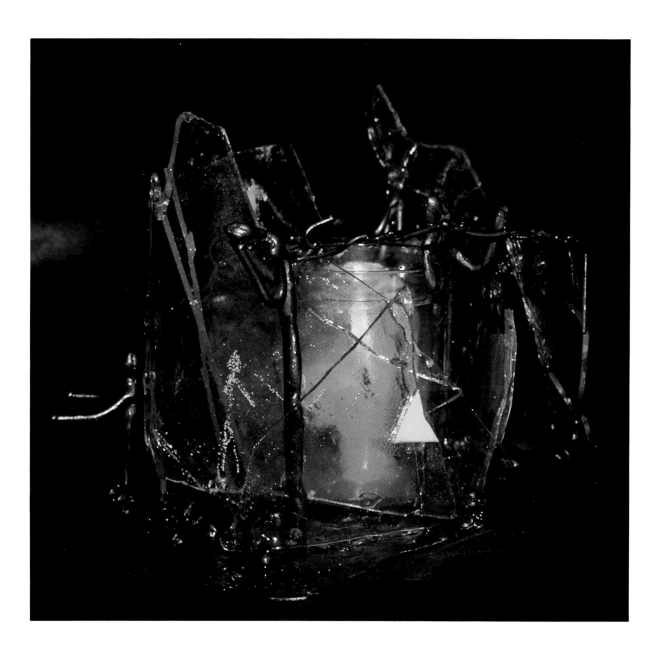

JULIE GOLDEN

UNITED STATES

Crystallvine

70 x 16 x 16″
182 x 41 x 41 cm
Glass on glass w/UV adhesive,
wood frame, German clockworks,
light in base.

BRONZE AWARD

I WAS RAISED IN A RELIGIOUS home. I ignored whatever exposure I had about Kristallnacht because it concerned unpleasantness about people of another religion. I had no room for the pain of other people I was taught to distrust.

Beliefs change slowly. Through the years I married a Jewish man, traveled extensively in Israel and learned more than I can express in a few words.

Habits change slowly, too. I still do not have the strength to name this work Kristall-vine or Kristallnacht. The horror and the facts of the Holocaust are a powerful element in my life, and I still fear the truth of it.

In this piece, the vine of Kristallnacht continues to be measured as it reaches out to other people, other times.

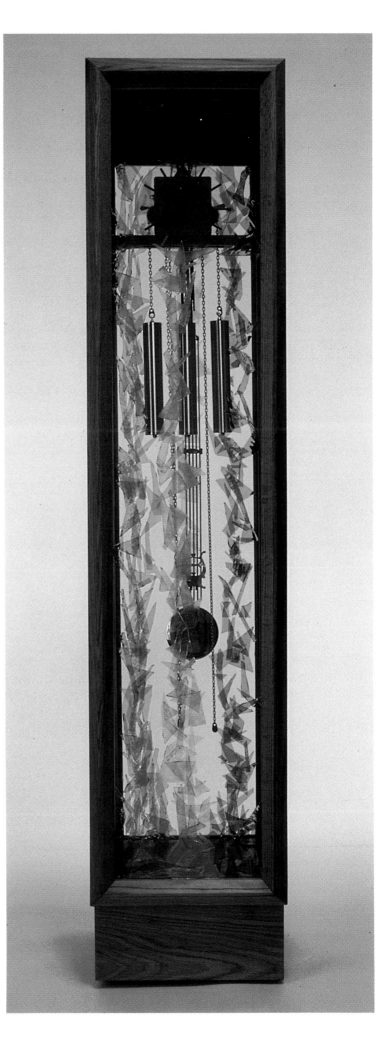

E. GAIL GUY

UNITED STATES

In Our Times

20 round x 8½″ high
52 cm round x 22 cm high
Fused metal to glass, slumped,
solder sculpture

BRONZE AWARD

FROM BROKEN GLASS TO IMAGES OF MILITARY HARDWARE, FROM religious symbols to limp doll-like figures of wandering and destroyed children, each element of this piece is connected on a mirrored base...the better to see ourselves reflected in the Holocaust that actually happened in our lifetime.

Like it or not, we are part of a civilization that watched families ripped apart. This, above all, can never be denied. This, above all, must never be forgotten.

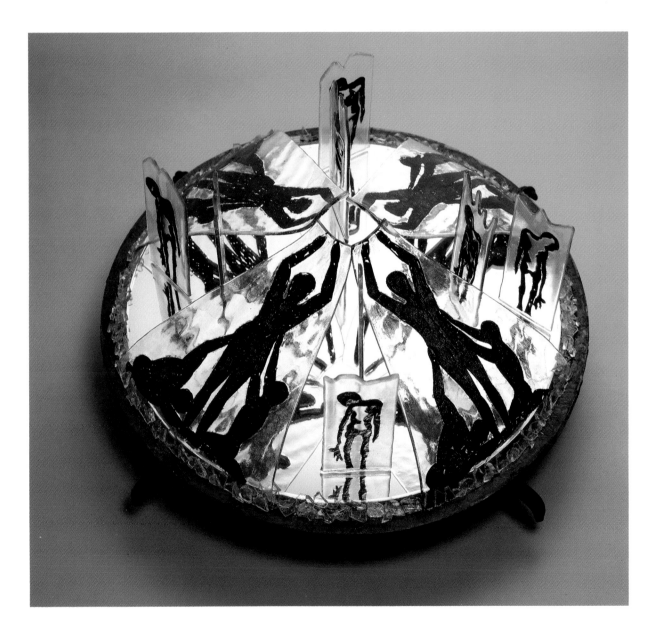

MARY GREGORY

FINLAND

Human Sacrifice

69 x 52"
172 x 130 cm
Leaded glass and painted
with rock

BRONZE AWARD

IT WAS IMPORTANT TO ME THAT THIS WORK RELATE TO THE memory of the Kristallnact massacres as well as to the present time. Specifically, I was interested in the comment so often made by the survivors—that the Nazi crimes of the Holocaust changed its victims forever. Clearly, the evils and destruction of that era still continue a generation after the fact, via the visions and perspectives of those survivors.

I wanted my work to reflect on the present generation, which is my own. The pain and conflict, therefore, had to be on an extremely personal basis.

As a survivor himself of the horrors of the war, my father brought into our household the residue of hideous realities and their related problems. This work is about my childhood and the destruction of a family unit as well as the hate and fear that were the aftereffect of the war.

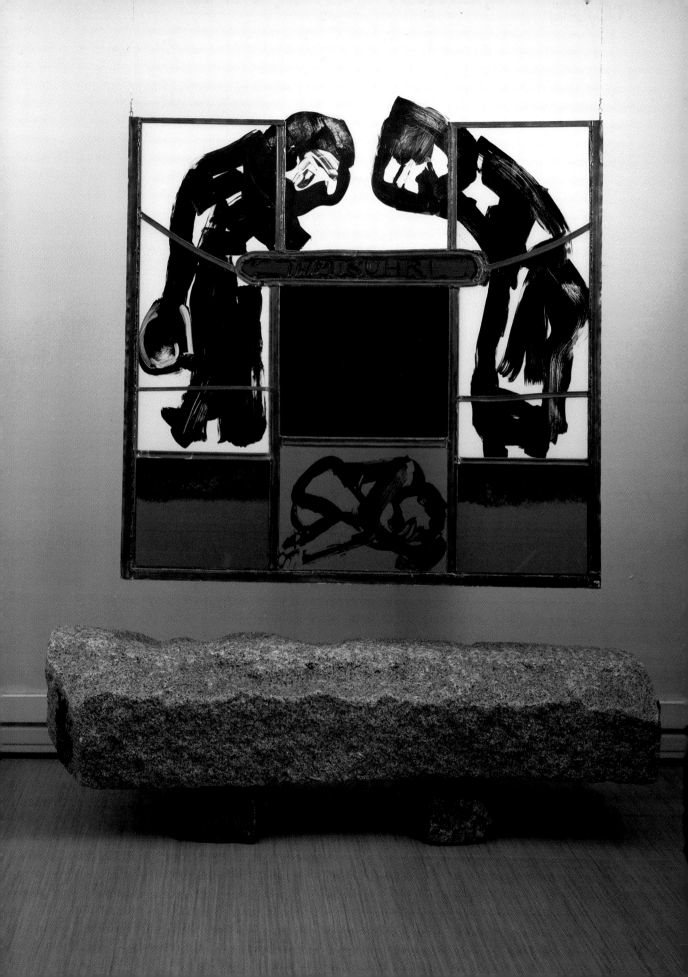

EKA HAEBERLING

SWITZERLAND

Lessons for a Small Child

15 x 18 x 18"
38 x 45 x 45 cm
Lampwork, sandblasted and painted.
Metal supports

BRONZE AWARD

Never forget what happened in the Second World War.
Never forget that blind obedience, oppression and fear
have consequences.
Never forget: the lessons of the Holocaust.
Never forget that freedom of thought and expression and of
religion are values that must be defended with courage and faith.
Never forget that art revives the spirit and teaches mankind
to revere freedom.

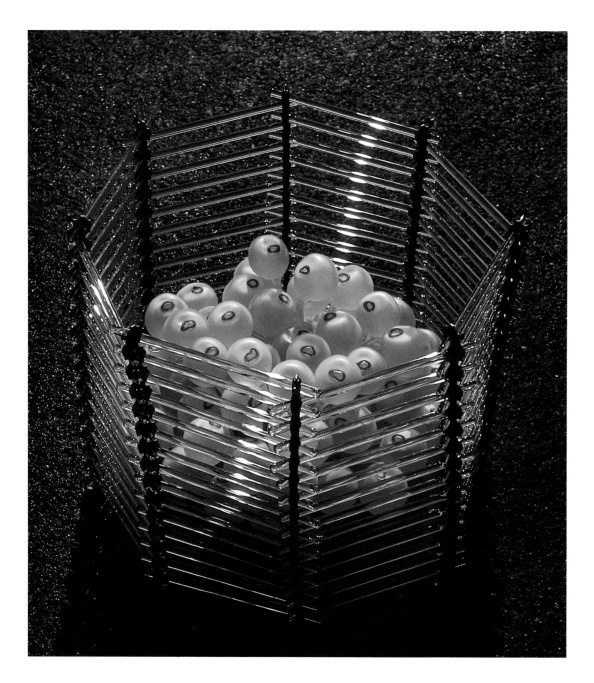

EDUARD INDERMAUR

SWITZERLAND

Schizophrenia 1938-1991

39½ x 17 x 10"
98 x 68 x 25 cm
Partly iridescent flat glasses, black
mirror. Deep and surfaced sandblasted
drawings and details, wooden frame
with illuminated effect.

BRONZE AWARD

IN FRONT OF THE FRAGMENTS OF AN IRIDESCENT AND TRANS-
parent panel, a multi-colored piece of glass, mainly red, is fixed on
a weak, slim thread. These are symbols of cramped individuals,
negated life and, ultimately, denied humanity, all within the split
wooden frame of Nazi schizophrenia.

MARTIN JIRICKA

CZECHOSLOVAKIA

Confrontation

66 x 28 x 6″
165 x 70 x 15 cm
Stained glass

BRONZE AWARD

COMING TO GRIPS WITH THE PAST AND CONFRONTING EVIL AND imposed brutality is a major task during this period when our political orientation is changing. It is a subject very much alive in Central Europe. The memory of pain, suffering and violence is not limited by time. Neither are submission and indifference.
Every form of terror has its own Kristallnacht.

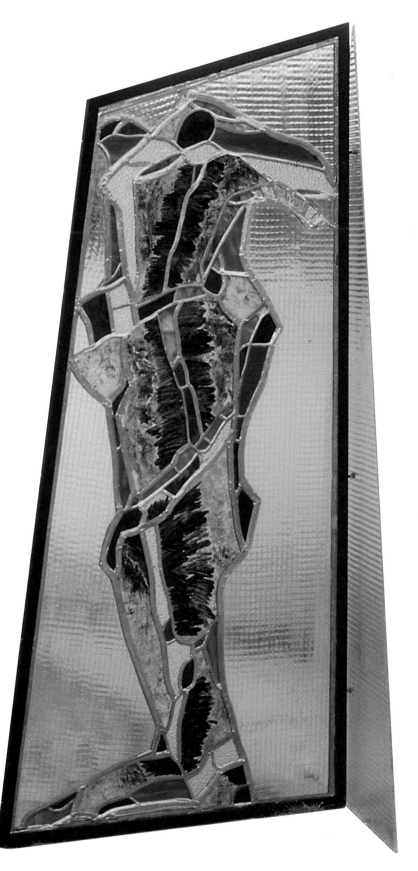

TONY JOJOLA

<small>UNITED STATES</small>

Connections

12″ round x 5″ high
31 x 13 cm
Blown glass

BRONZE AWARD

EVERY FORM OF PREJUDICE MUST BE CONDEMNED. FOR TOO long no one spoke out in protest against the atrocities committed by the invaders of the new world against the inhabitants they found in the western hemisphere.

My people and I, native Americans, know what it means to be victims of great prejudice and hate. Like those people persecuted during the Holocaust, we, too, have fully tasted the injustice of being denied one's own home and land, of forced relocation, of being stripped of our religion and systematically wiped out. Today the courage of native Americans holds fast as we honor our traditions. We, too, maintain our balance in this fast, demanding society by cherishing our religion, ancient language, beliefs and customs. We endure, and yet we are like all people—fragile.

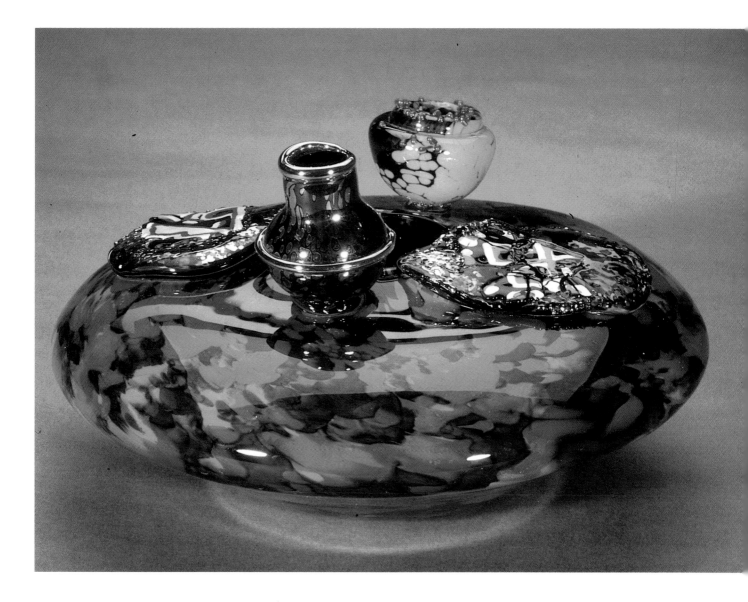

102

LUDWIK KICZURA

POLAND

How Dreadful is this Place

14½ x 8½ x 3⅛″
36 x 21 x 8 cm
Crystal and optical colored
glass, polished, glued

BRONZE AWARD

I SAW IT MYSELF . . . THE TRANSPORTATION OF OUR JEWISH citizens from the Lwow ghetto to the neighboring forests in Bialochorszcze, where they were killed.

My work is a documentation of this remembrance. It shows the vast tomb and the crack caused by fire. All elements are connected with each other.

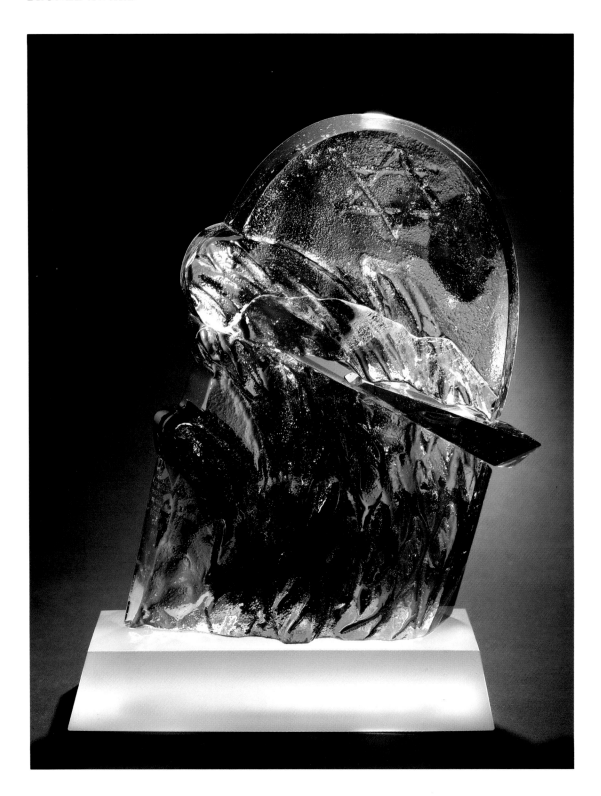

LUCARTHA KOHLER

UNITED STATES

*From The Shards
 of Kristallnacht*

14 x 8 x 8″
36 x 21 x 27 cm
Cast forms (glass) assembled
with shards of glass

BRONZE AWARD

From The Shards of Kristallnacht a new spirit is born.

*This is a spirit that is noble and courageous,
 that is vulnerable and fragile,
 that is waiting to be molded and etched,
 that may shrivel and die with the poisons of hate,
 that needs the love of all humankind in order to grow and flourish.*

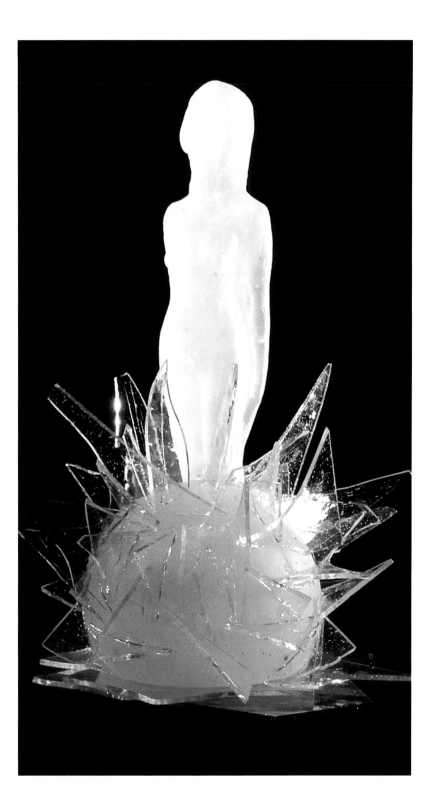

KAI KOPPEL

Estonia

Hope

7¹⁄₁₆ x 5⅞"
48 x 15 cm
Engraved crystal

BRONZE AWARD

To discover the richness of the visual world is to discover life. The idea of the eternity of beauty has encouraged me to discard obedience to capricious, ever-changing fashion. I believe that Picasso must have felt similar joy entering his neoclassical period.

I want my work to connect and identify with the Song of Solomon, rather than the night-marish spirit of the Kristallnacht.

Recent experiences at home in the trouble-stricken Baltics have affirmed my need . . . my desire to view the theme of this project from my own standpoint. For us here, every moment is pregnant with the frightening possibility of a tragic outcome. Nothing less than the destiny of a whole nation is at stake.

Clearly, the potential catastrophe that faces my country has a painfully strong flavor of reality that has very little to do with the aesthetic categories.

So, in defiance of the gruesome reality, my theme for the Kristallnacht exhibition is one of hope that I would like to associate with the joy of life, kindness and beauty.

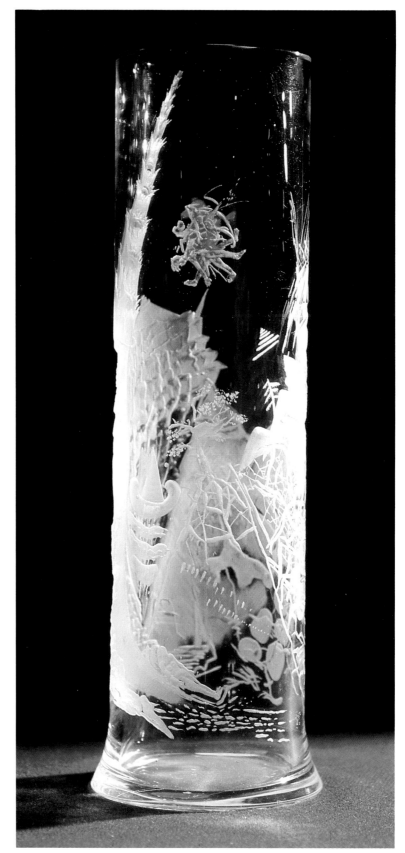

IRENEUSZ KIZINSKI

Poland

Epitaphium

11 x 3½ x 5⅞"
28 x 9 x 15 cm
Crystal glass, hand formed,
saw cut, glued

BRONZE AWARD

As a five-year-old, I was twice forced by the Nazis to witness the executions of the partisans. In both cases they were carried out by pistol shots fired at the back of their heads from the distance of a few paces. The atrocities of those events and the barbarisms of the Nazis left a deep scar.

My work is branded with bitter recollections of those days and bears the mark of my clear and personal visions of the Crystal Night.

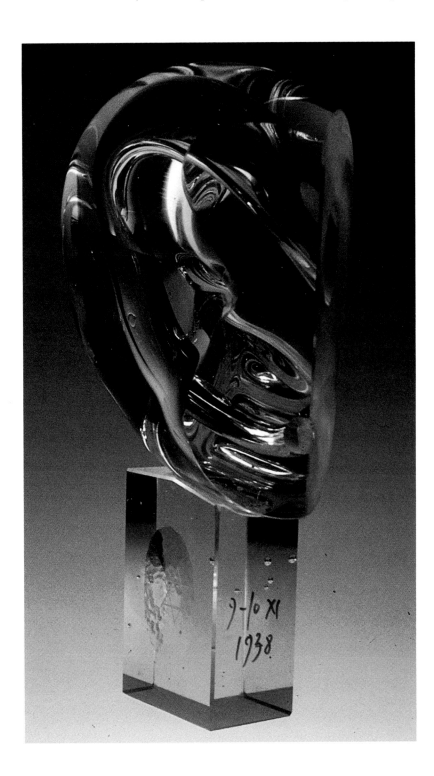

105

LISABETH LEVINE

UNITED STATES

The Ghetto Is On Fire

11½ x 14″
29.3 x 35.4 cm
Painting on glass

BRONZE AWARD

THE REBELLION AGAINST THE OVERWHELMING NAZI BATTAL-
ions was a futile last-ditch effort by the Jewish youth trapped in the
Warsaw ghetto. They understood the "Final Solution" that was
awaiting them. They bravely held off the experienced German
regiments who used flame throwers to brutally destroy their resis-
tance.

The finality of the flames, the pain, the hideous torture that
those incredibly courageous youngsters faced . . . are the images
that this work is meant to reflect along with a world of unanswered
questions:

Why do people inflict war, genocide, racial beatings and the
more subtle effects of discrimination upon one another?

When will purveyors of hatred learn to respect the dignity of
human life?

When will they stop claiming God is on their side?

We are all capable of joy, sadness and terror. We all love our
children. Because we share the fragility of the human experience,
it is incumbent upon each of us to treat others as our true brothers
and sisters.

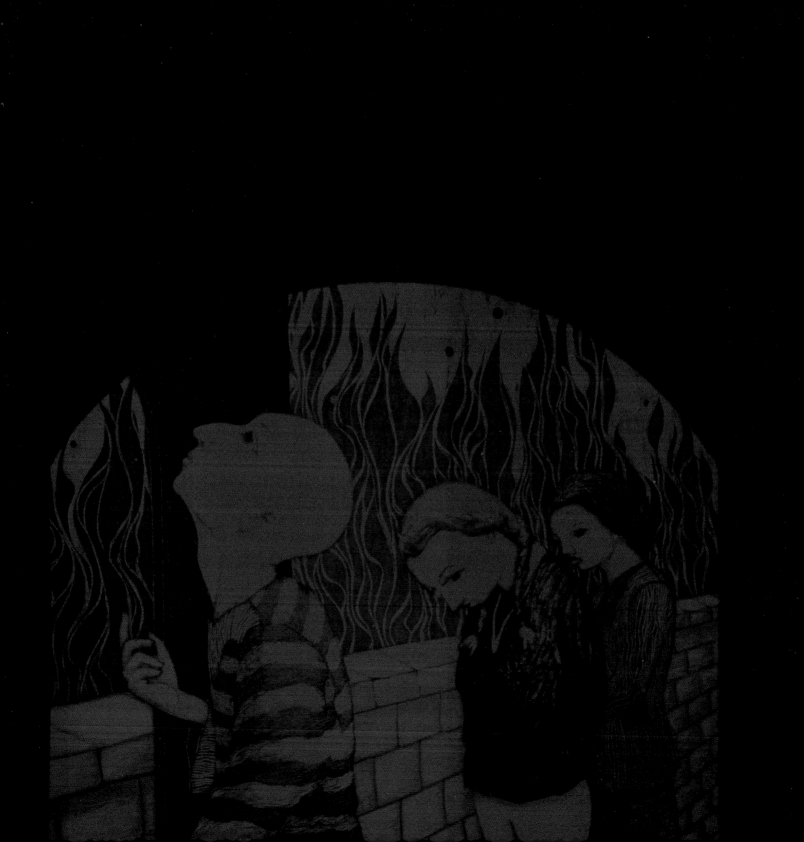

**KAREL MIKOLAS
LOUIS KAHN**

United States

*Maquette of the Louis Kahn
Holocaust Memorial*

16 x 18 x 3½"
41 x 46 x 9 cm
Plate glass, Amazon mahogany
and bronze

BRONZE AWARD

THE STRUCTURAL CONCEPT OF THIS PROJECT CONSISTS OF 9 massive glass forms, each column approximately 9 to 12 feet high; standing in granite.

Louis Kahn's wishes were that the memorial not be narrative or graphic in its depiction of the atrocities of the Holocaust. On the contrary, his desire was that it be a calm place for visitors to celebrate life. Natural light is a main ingredient.

My maquette of his monument is dedicated to the memory of this great painter, sculptor, craftsman, teacher, architect.

His lifetime of work confirmed the unmeasurable truths which a work of art reveals. In his hands, every medium touched its limit, revealed its nature, and was given radiance through his choice of mass, shape, line and color.

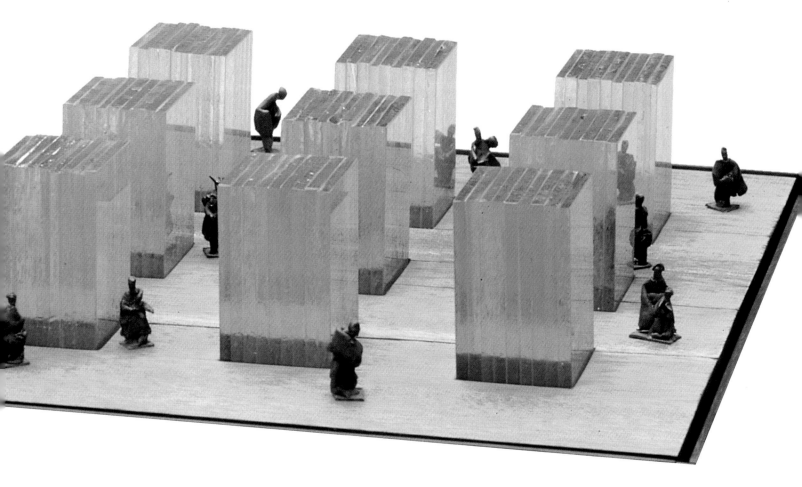

ROGER NACHMAN

UNITED STATES

A Survivor's Face

20½ x 38 x 1″
52 x 99 x 3 cm
Plate glass; etched, sandblasted and
fired with enamels; fused with silver,
copper and aluminum leaf

BRONZE AWARD

AS I BEGAN THE PROCESS OF CREATING THIS WORK, MY HAND began drawing individual faces. Faces that felt, that had experienced pain, loss, horror. Faces that were tortured, sorrowful and incredulous with the inconceivable acts they had witnessed.

I have focused my remembrance of Kristallnacht and the Holocaust on the people who survived. Shocked and devastated by what they had seen and experienced, they have, somehow, held onto their hopes and beliefs. These people instill in me a drive to live my life with meaning, to be thankful for the abundance we have and to make certain that such catastrophes never happen again.

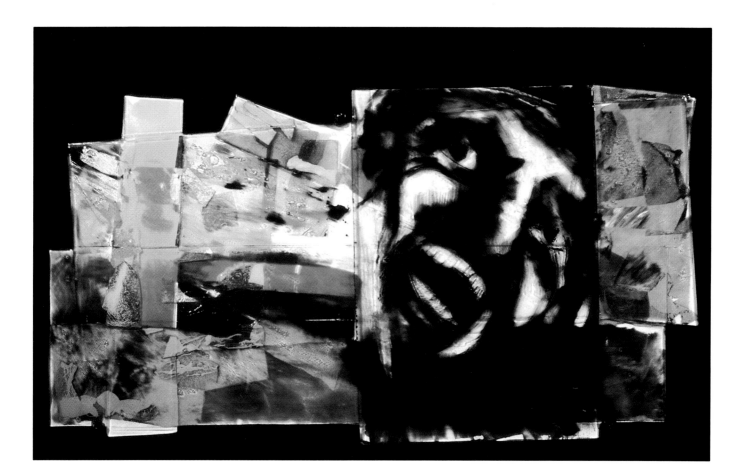

VINCENT LEON OLMSTED

UNITED STATES

Souls of the Holocaust

27 x 6 x 6"
70.2 x 15.6 x 15.6 cm
Blown and cast glass, copper,
electro-formed cement

BRONZE AWARD

I CANNOT PRESUME TO EVEN IMAG-ine the scope of the suffering and anguish that existed throughout Kristallnacht. And when one con-templates that this night was only the beginning of the nightmare created by the Third Reich, the heart trembles.

The suffering of an entire people did not cease after that night or even after the war ended. There are many people who today live with the physical scars of that time as well as the mental scars which, ultimately, are more long-lasting.

The Holocaust continues to scar succeeding generations. It is a blight on our souls.

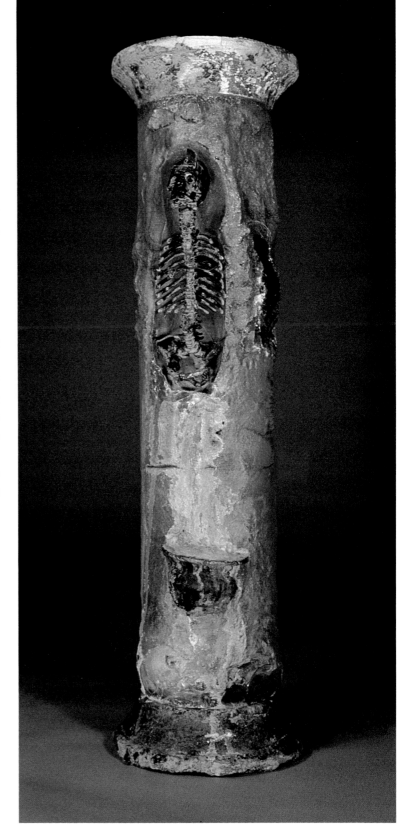

KAZIMIERZ PAWLAK

Poland

Moses' Tears

40 x 40 x 3 cm
100 x 111 x 1 cm
Cut optical glass, glued, polished

BRONZE AWARD

My stone tablets are broken like the shattered glass of November 9, 1938. The little red glass balls? They are Moses' tears.

They said that Moses cried as he smashed the sacred stone tablets on the rocks. Perhaps he cried on Kristallnacht, too.

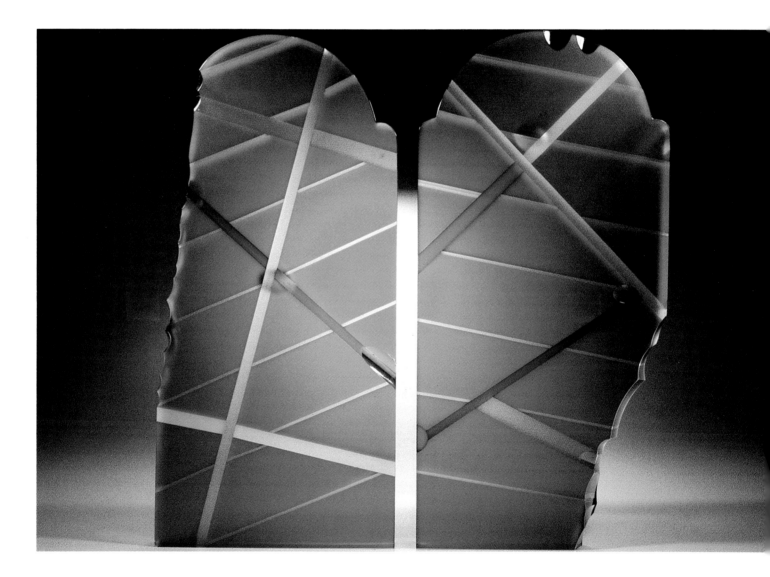

112

NEIL ROBERTS

Australia

A Bullet and A Breath

2¾ x 10¹⁄₁₆ x 2¾″
7 x 25.5 x 7 cm
Metal and glass

BRONZE AWARD

A Bullet and A Breath concerns violence and its partner, death. Each act of violence has a 'volume,' a space it occupies in the scheme of things that is the equivalent to the volume of air expired at death.

Metaphorically, the glass describes the final fragile breath that marks the end of a human spirit when violence is enacted.

For every final breath that was produced by the violence of the Holocaust, there is a bullet lodged in the soul of mankind. No patina of age will ever be able to dislodge it.

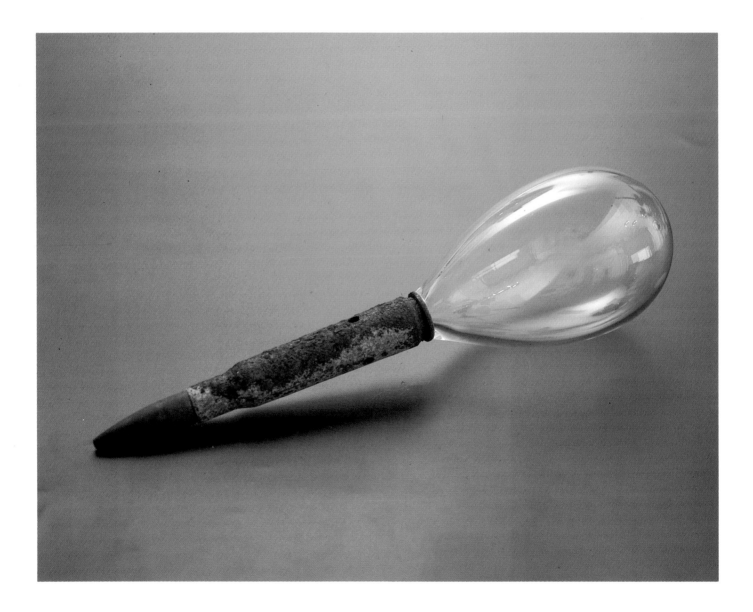

STEFAN SADOWSKI

<small>POLAND</small>

The Silver Dreams of Anne

13 x 13½ x 2¾″
34 x 35 x 7 cm
Crystal and marble

BRONZE AWARD

<small>WITHIN THE PROCESS OF EVOLUTION, MANKIND HAS, AT TIMES</small> practiced cannibalism. On November 10, 1938 and throughout the Holocaust that followed, there was a return to that barbarism. As part of eating the very souls of their victims, the Nazis used gas chambers, crematoriums, ovens to render human fat mills to make fertilizer from human bones and more.

The Silver Dreams of Anne is made from crystal glass on a white marble base. It recollects the reality and scope of bestiality while embracing Anne Frank's dreams in the Bergen-Belsen concentration camp of a whole and happy life not faded nor gone.

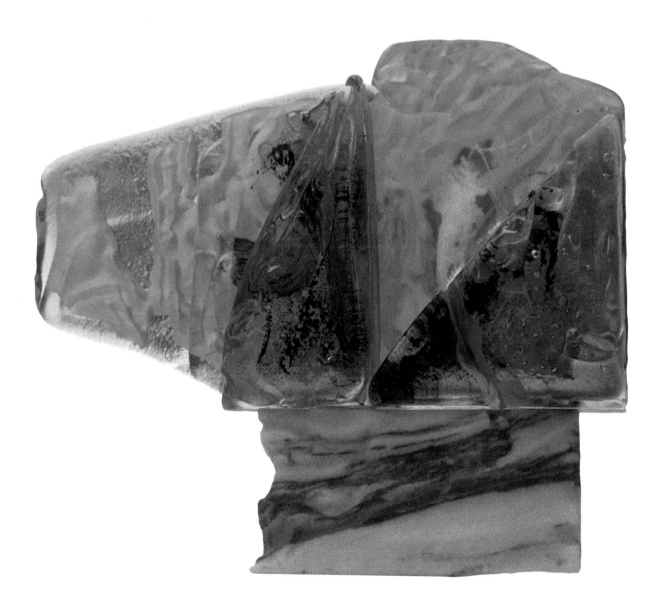

ERIKA STEPHAN
UNITED STATES

Haunting Images

19 X 20 X 25"
49 x 52 x 65 cm
Clear and dichroic glass slumped
over plaster masks and barbed
wire, mounted on black glass

BRONZE AWARD

THEY KEEP COMING. IMAGES AND STILL MORE IMAGES—OF
people trapped in the terror and death of the camps; of broken glass
and the torn lives of victims; of barbed wire, inhuman captivity; and
shattered dreams.

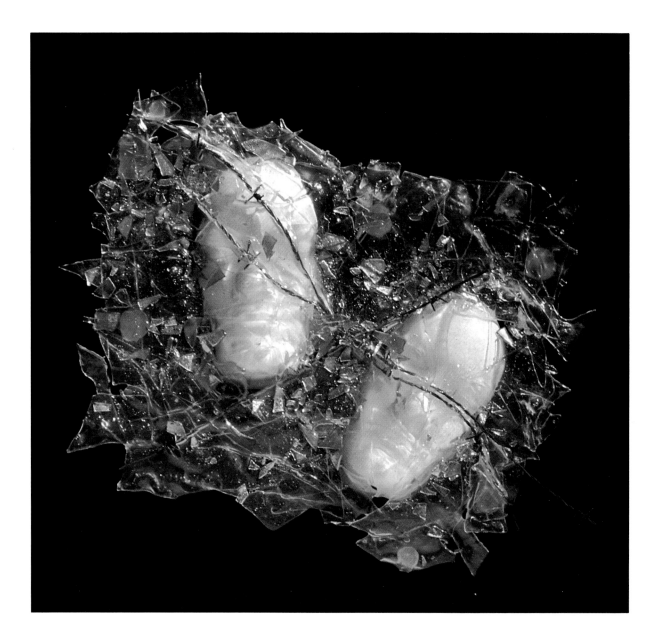

ROBERT STEPHAN

<small>UNITED STATES</small>

Kristallnacht Looking Glass

21⅛ x 21⅛ x 1⅛"
55 x 55 x 3 cm
Welded steel frame with applied
fencing and barbed wire, chipped
glass, vacuum mirrored

BRONZE AWARD

<small>TAKE A MOMENT. ALLOW YOURSELF TO FEEL THE FEAR RISING</small> in your throat, to glimpse an imprisoned familiar face, to reflect on the role of barbed wire throughout the Holocaust as an instrument of hate and prejudice, of violence and terror. *Step into the "Looking Glass." See how it fits.*

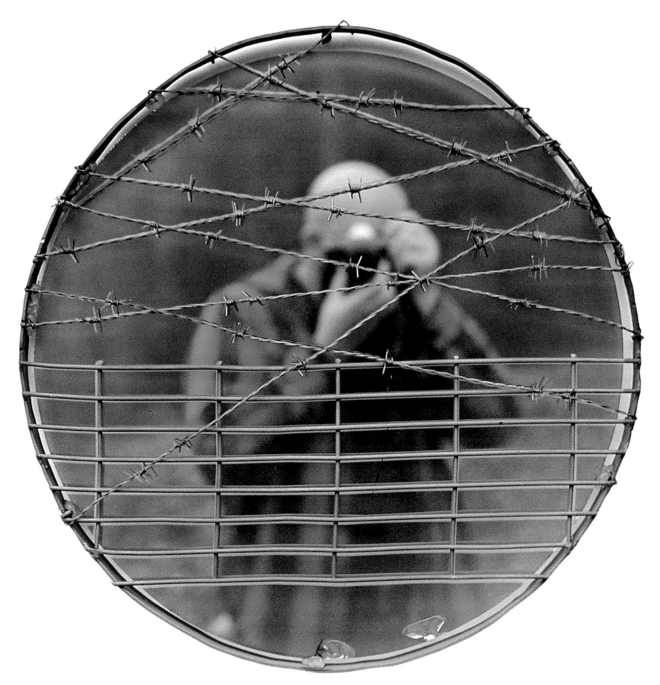

ALISON SHEAFOR

UNITED STATES

Mengele's Twins

10 x 20 x 11"
26 x 50 x 28 cm
Blown glass, slumped glass,
steel and wood

BRONZE AWARD

I AM NEITHER JEWISH NOR GERMAN, NOR DO I HAVE CLOSE TIES
with anyone who was actually involved in the Holocaust. When I
heard about this exhibition I wasn't certain that I had the right to
make a piece about something so intimate to other people. But in
the weeks that followed, the theme of Kristallnacht resurfaced again
and again, and I couldn't deny the sculpture that I saw forming in
my mind's eye. I finally sketched my idea and went to work.

I remembered the time in my twelfth grade world history class,
when the teacher brought in six hours of films from the concentra-
tion camps before and after their liberation. Even now I can re-
member the silent black and white images and the feelings I had
while watching . . . nauseated and overwhelmed. My mind keeps
recalling the images of people looking out through the barbed wire
fencing. Just standing there, staring.

This work is a specific reminder of the barbaric surgical pro-
cedures of the German doctor, Josef Mengele, who performed
horrifying medical experiments on healthy Jewish twins throughout
the Holocaust in the name of the Third Reich and the "final
solution." The curious soft blues and purples of the back wall of the
sculpture represent mountains and sky, the world the twins looked
out on each day desperately hoping for life . . . a hope that was
almost always denied.

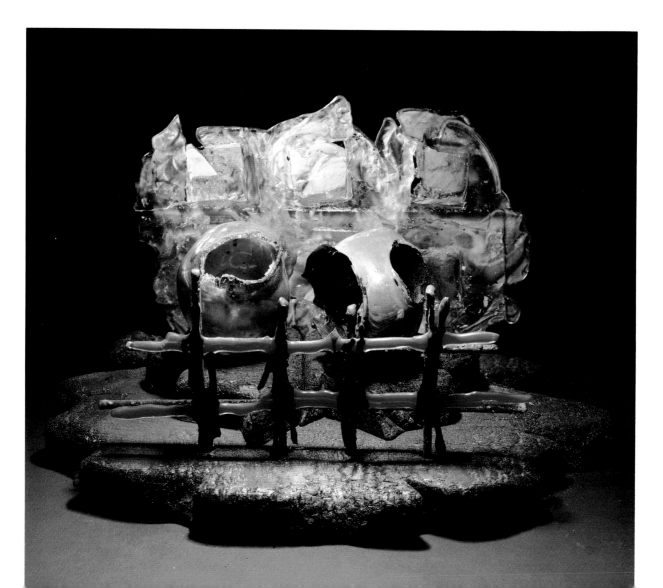

JULIE STEWARD

UNITED STATES

*We are Orphans
 and Fatherless,
 Our Mothers
 are as Widows*

6¾ x 8 x 8″
16 x 20 x 20 cm
Drill engraved on lead crystal vessel

BRONZE AWARD

WHEN I WAS QUITE YOUNG, I SAW PHOTOGRAPHS OF THE REsults of the Nazi "Final Solution" on television. I was horrified. Not only by the ruined bodies, but by the fact that human beings actually committed these crimes.

My grandmother told me that these tragic victims were people of God; that they were our brothers because our Lord also was a Jew. Seeing what happened to even the chosen people made me very wary of possessions and relationships. I have dedicated all my children to the Lord, nothing to myself, but to God, if He might require the return of any.

When I studied books and histories on the Holocaust for this exhibition, it seemed that of all the cruelties, the most severe were the intentional separation of mothers from children, grandfathers from grandsons, brothers from sisters. The survivors whose biographies I read could tell of torture and shame, but the loss of a mother, husband, child . . . this was almost unspeakable.

This engraved vessel is to testify to the worst of these crimes.

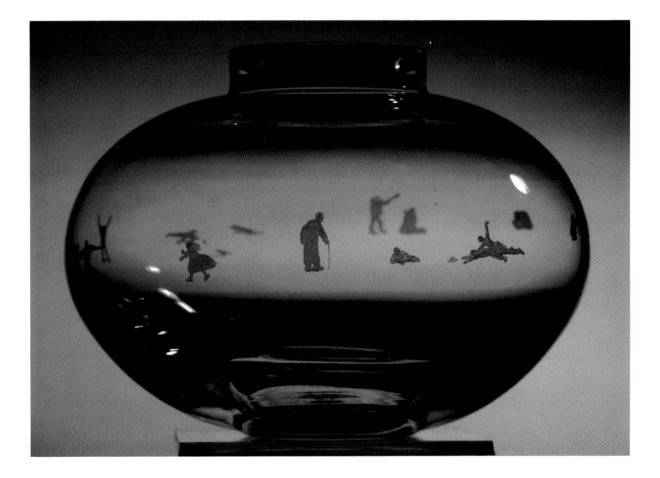

MARGARET STONE

UNITED STATES

Meditation on the Sands

38 x 48 x 7″ base
99 x 125 x 18 cm
Kiln formed glass

BRONZE AWARD

GRANDPA DIDN'T HAVE ANY EYEBROWS, HIS EYELASHES WERE gone too. He was a quiet man. As a child, I sensed a certain sadness in him. I would ponder his pink-rimmed eyes, curious yet unable to ask him "Why?" So I asked my mother. "Grandpa is a Russian Pole," she said. "They had him working in a forced labor zinc factory. It burned away his eyebrows and eyelashes. They never grew back. He fled . . . he fled for his life."

My work relates to the slave labor camps and the Holocaust. I had no direct experience to draw on for this piece. What I had heard and read were words, words about incomprehensible acts that began to mix with my feelings in an angry stew. I would wake at night with half-formed visions, a heavy feeling in my chest. In the studio, those visions flowed and merged in the glass heated by the kiln.

The naked form gives birth to the child who knows no life. Empty eyes search caverns of despair, and humanity burns in chaotic red hatred.

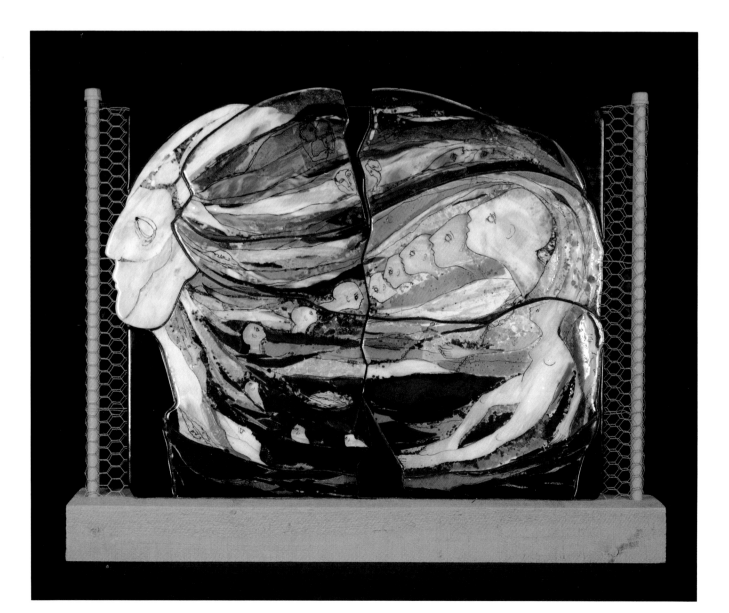

BRUNO VAN DIJCK

<small>BELGIUM</small>

Kristallnacht

40½ x 21 x 5″
102 x 51.5 x 2 cm
Glass, polyester

BRONZE AWARD

WITH THIS WORK I WANT TO MAKE CLEAR THAT YOU CANNOT fully repair glass. At the most, you can glue it together and try to cover up the broken pieces.

The personal freedom of all living beings is one of God's glories. The limitation of that freedom for one is anathema for all. Don't permit anyone's glass to be shot at or stoned. Yours may be next.

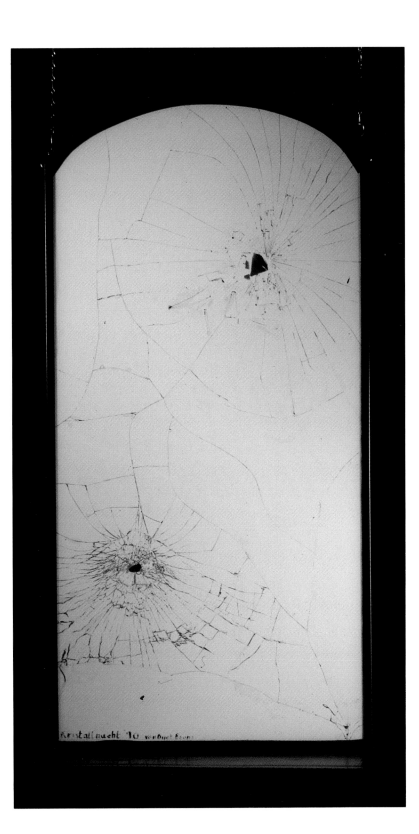

EVA VLASAKOVA

C<small>ZECHOSLOVAKIA</small>

House of Dreams:
 Anne Frank's House

11¼ x 13½ x 6⁵⁄₁₆″
28 x 34 x 16 cm
Cast glass and painted

BRONZE AWARD

S<small>INCE CHILDHOOD</small> I <small>HAVE HAD CLOSE</small> J<small>EWISH FRIENDS</small>. I have learned about their suffering and that of their families during the Holocaust. Through it all they have held fast to a living faith that touches, that gives roots to every human being, that rises above the tragedies of hate and violence. There have been moments when I wished to be one with them and wear the yellow Star of David on my breast.

This work honors the memory of their courage.

Visiting Amsterdam I have observed numbers of visitors coming to see the Anne Frank house. People from all around the world, mostly youth, enter with talks and smiles, so suitable to their age. Most of them leave very quietly, without a word, with eyes full of tears.

What I wanted to show in this work is that Anne's house was, in fact, her House of Dreams. This beautiful, sweet, short-lived child/ woman left us unforgettable testimony about those dreams.

I wished to change that narrow dark attic into a sparkling crystal space, full of sun, the smell of fresh flowers and flying birds .

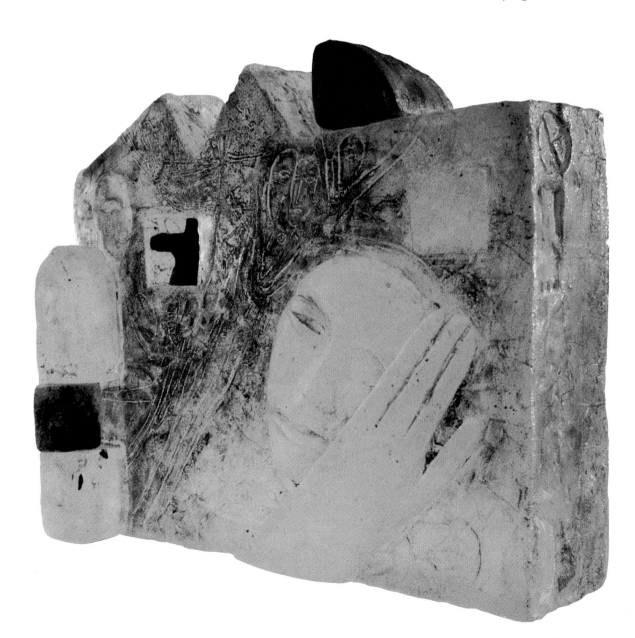

JAN VOTAVA

CzECHOSLOVAKIA

*The Sorrow
—The Pieta*

14½ x 14½ x 6″
36 x 36 x 2.3 cm
Sandblasted flat glass

BRONZE AWARD

I HAVE CREATED MY WORK AS A *PIET* REMEMBRANCE OF VICTIMS of the Holocaust in Germany. This work is a connection of two symbols. The face of the sun, the symbol of life, is hidden behind the Madonna vesture—the symbol of sorrow.

In addressing the theme, I have intentionally used symbols that can psychologically evoke man. People dare not forget the night of November 9, 1938. We must have the courage to teach, to recall it year after year.

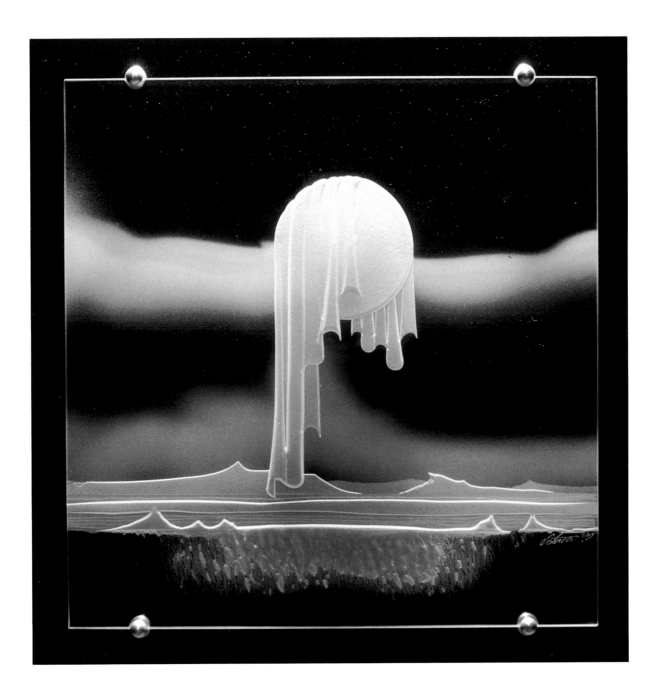

122

ILSE WAGNER

SWEDEN

Remembrance

19½ x 19½ x 2⅜"
50.5 x 50.5 x 6 cm
Antique glass with
applications, three
dimensional, enameled, leaded

BRONZE AWARD

REMEMBRANCE REACHES FROM THE BROKEN WINDOWS OF Kristallnacht to the millions of deaths and the stark cemeteries of the Holocaust.

My work was created to remind people of mankind's darkest period . . . those years between Kristallnacht and the "final solution."

May God help us to strike down each new sign of intolerance, prejudice and hate. May God help us to feel those sharp splinters of glass and to recognize the pain as our own.

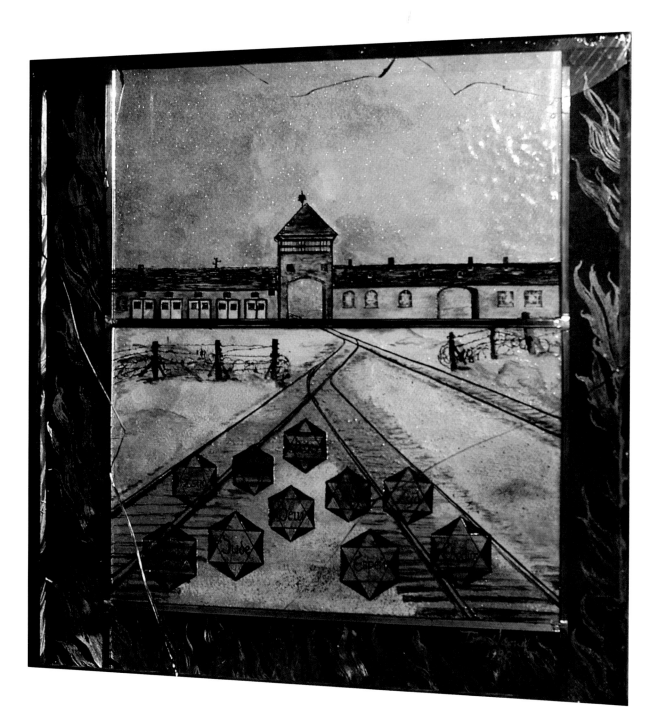

HANS-JURGEN WOLFF

<small>GERMANY</small>

Dangerous Puppet

14¾ x 11½"
42 x 30 cm
Stained glass

BRONZE AWARD

As a German I feel enormously uneasy when I think of the Reichkristallnacht. It was a strong desire for dominance linked to blind obedience that degraded and split the nation and turned it into a mechanical tool for the fascist rulers.

Our society worked like performing marionettes. And once again, Jews were driven into the abyss.

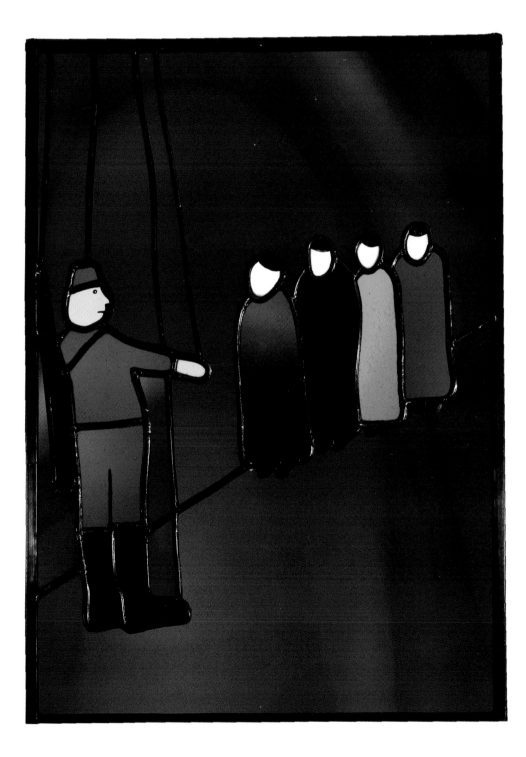

124 **SHAUNA WALSH**

UNITED STATES

Time and The Spirit

11 x 15¼ x 11¼"
28 x 39 x 29 cm
Plate glass shards embedded in
cement. Slip cast-porcelain rakued
head on base of bricks

BRONZE AWARD

THE END: Shards of glass as in a shattered storefront window on the sidewalks during Kristallnacht.

THE BEGINNING: A raised head celebrates the indestructibility of the spirit. It survives in glory and hope, in spite of the persecution and murder of millions in the concentration camps.

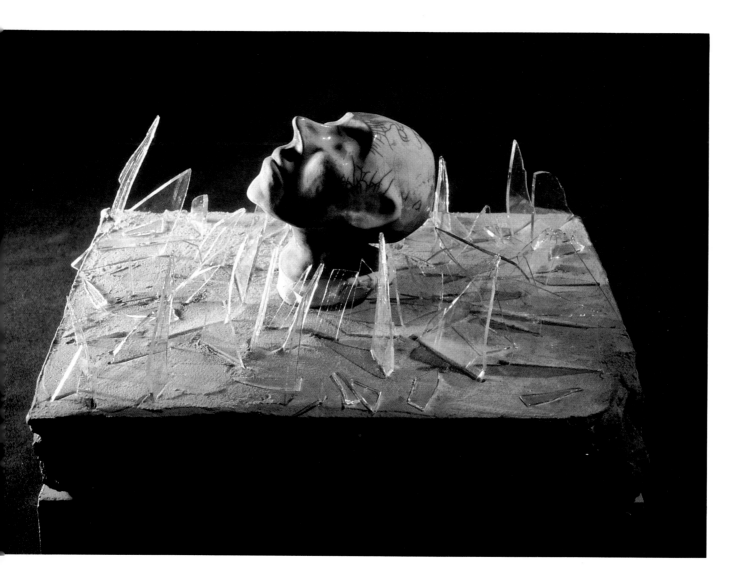

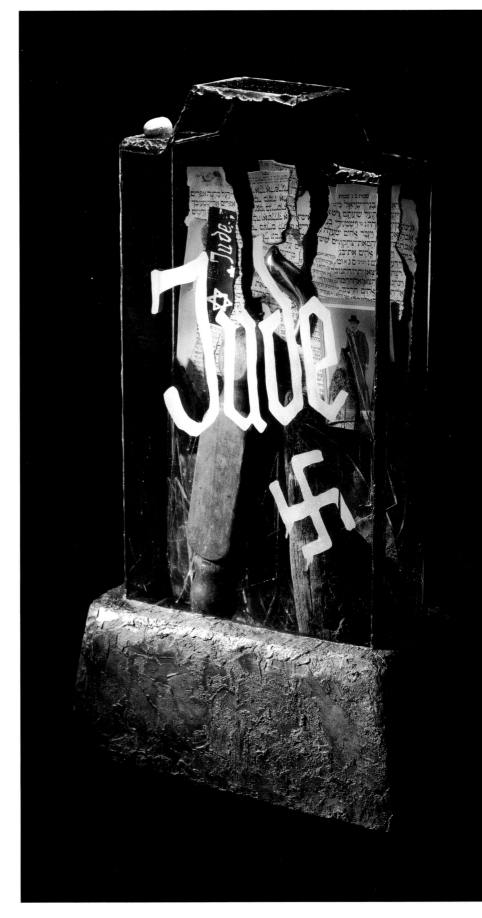

IRVING WARHAFTIG

United States

JUDE . . . Yisgadal

22½ x 14 x 7″ base
58 x 36 x 18 cm
Glass collage—glass, paper, wood, stone

BRONZE AWARD

THIS CENOTAPH IS TO MEMORIALIZE forever the hideous destruction of a people that was launched that fateful night of Kristallnacht.

The collage includes shattered glass fragments representing Jewish culture and contributions to humanity. The burned wood represents the hollowed shells of synagogues, stores and homes burned to the ground. The pages of the prayer books torn, burned and singed speak of centuries of intellectual and spiritual teachings.

The overall form is based on old cemetery stones. The pebble on the corner is traditionally left behind at a funeral as a remembrance—never to forget. Never to forget the organized death of so many, especially the children. Never to forget the imprisonment and killing of two million young Anne Franks, the ultimate genocide, for with them perished generations of hope and potential.

It is essential in this once-again fragmenting world not only to recall the lessons of that time, but to work hand-in-hand and heart-to-heart with our brothers and sisters to passionately insist, "Never again!"

ROLF WALD

United States

Dachau Tourist

16 x 16 x 72"
41 x 41 x 187 cm
Blown glass, barbed wire,
wood base, welded frame

BRONZE AWARD

I visited Dachau concentration camp on a bitterly cold, rainy day in February 1975. Despite my down parka and heavy winter gear, I was chilled to the bone as I sat in the small theater watching the films taken by those excruciatingly efficient Nazis to document their deeds.

Even more chilling than the weather were the scenes of naked prisoners hanging from crosses in the snow. Row after row of skeletons with faces and shaved heads stared back at the cameras, as though the sorrow they had experienced had long since drained all the life from them. There were old and young, men and women, and children; and in such numbers!

The townsfolk of Dachau saw the trainloads arrive bearing their human cargo and depart empty. They couldn't escape the stench of the ovens and its terrible evidence of human destruction. They knew what was going on. The movies were in German, and I didn't understand all of the words, but the images burned themselves deeply into my memory. I felt extremely cold from them, more so than from the freezing rain.

I was 6'5", 200 pounds, 18 years old and in excellent health. The cold was already making me miserable, and the film I was watching filled me with horror that such inhumanity could run rampant.

As I toured the ovens, the smell of the human coke was still overwhelmingly awful even after thirty years. The hardest images to deal with were on the inside walls of the bunkhouses where prisoners were held while the death machine struggled to keep up the brutal pace of destruction and disposal. It was here that prisoners awaited their dismal fate, here that they had their last opportunity to leave the mark of their suffering upon the world. The initials, dates and short messages scratched into the wallboards were left by human hands as the absolute and final expressions of human souls.

As an artist I try to make beautiful "things" for people to enjoy and, hopefully, to distract them from everyday life and to help them see things differently. Most of my work is very abstract and can be interpreted as the viewer sees fit. This sculpture is a cathartic response to my trip to Dachau. The rewriting of history is an Orwellian-prophecy, and it infuriates me that some would try to deny the truth.

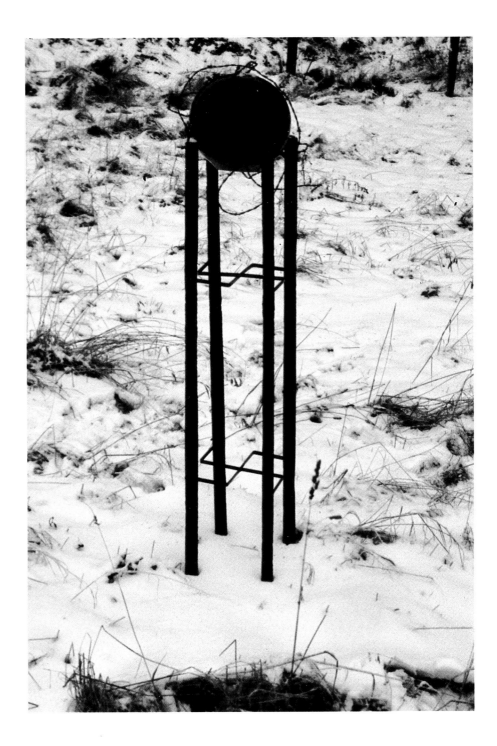

128

ELKE WERCHAN

<small>GERMANY</small>

Anne's Shoes

18½ x 18½ x 3¼"
46 x 46 x 8 cm
Metal melted into crystal glass

BRONZE AWARD

Anne's shoes . . .
Unusable, scorched,
A cruel relic from hopeless times.

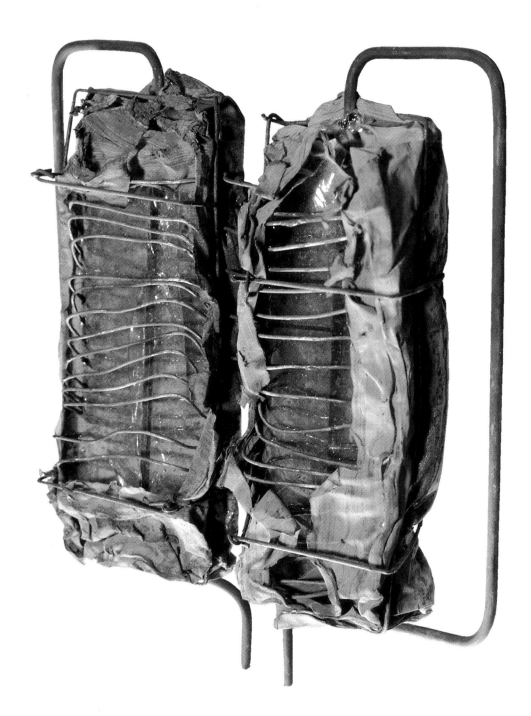

PETER ZELLE

UNITED STATES

Prisoner

68 x 12 x 5″
176 x 31 x 13 cm
Cast glass, welded steel

BRONZE AWARD

WHEN I VISITED THE ANNE FRANK House in Amsterdam, I was overwhelmed by the fear and confinement the Franks must have felt. I tried to taste it, to imagine no sunlight passing through the space and the darkness of what was happening beyond those walls. After my return, I sank into their feelings of being trapped, knowing that certain death awaited outside.

This struck me as the paradox of their situation. Their hideaway was both a prison and a fortress. Despite being confined on both sides of the wall, the Frank family and their fellow attic prisoners resolutely maintained a sense of self and a hope for survival that conquered and transcended their barriers.

Ah, the wonder and courage of those people!

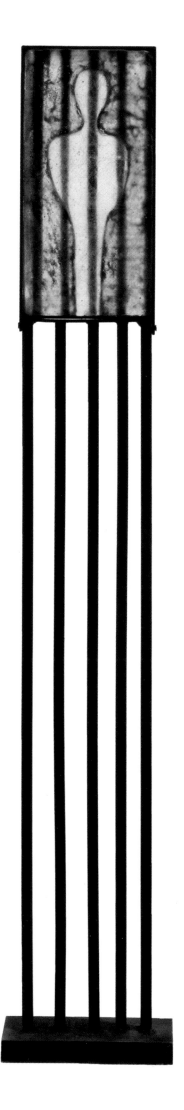

JAN-WILLEM VAN ZIJST

Belgium

Rosenhoet

12 x 15½"
80 x 40 cm
Glass and rosewood

BRONZE AWARD

THE ROSENHOET IS THE NAME FOR THE CROWN OF THORNS used in a Dutch cavalry song in the 15th century. The Crown of Thorns is a symbol so vast, it fills every corner of our heart and has come to represent all the suffering and brutal pain heaped upon innocents.

According to the Gospels, the Roman soldiers placed a Crown of Thorns on Jesus' head before they crucified him. In this century, the Nazis had their own form of crucifixion and the Rosenhoet which they placed on the heads of contemporary Jews and others throughout the Holocaust: torture, starvation, poison gas and other barbaric kinds of murder.

This Rosenhoet is
about light and dark,
about life and death,
about love and hate.
It presents a timeless image
that links sharp glass shards,
man in his time and fragments in space.

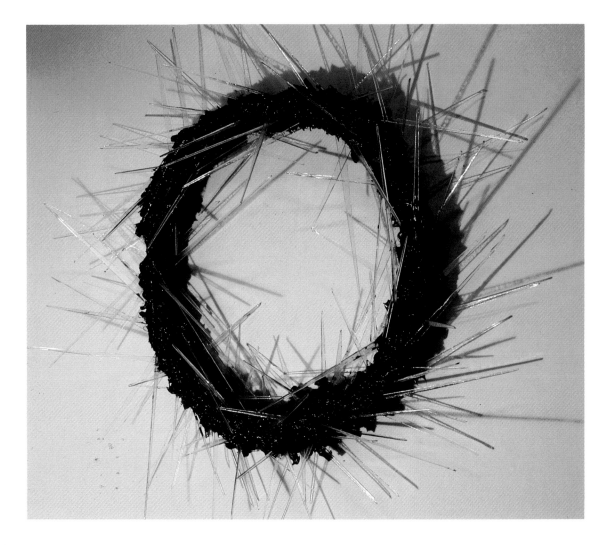

ARTIST DIRECTORY

Fumio Adachi
2-19-1 Minami-Nagasaki
Toshima-ku
Tokyo 171, Japan
81 3 3951-7877
Pages 14-15

Lynne-Rachel Altman
16 Gravatt Drive
Berkeley, California 94705
USA
415 848-6337
Page 80

Michael J. Aschenbrenner
246 Lafayette Street
New York, New York 10012
USA
212 226-8548
Page 81

Dan Bancila
Street Vladeasa 11
bloc C33, apartment 17
Bucharest, Romania
72-4672
Page 48

Gila Bar-Tal
10 Chaviva Reich Street
Givatayim 53453, Israel
97 2 33 23663
Page 82

Gerhard F. Baut
46 Chestnut Street
Swoyersville, Pennsylvania 18704
USA
717 288-8334
Pages 84-85

Andi Biland
Hauptstrasse 119B
CH 5262 Frick, Switzerland
064 61 45 78
Page 86

Gilat Blecher
Hess Street 4
Tel Aviv 63324, Israel
97 2 3 65576
Page 88

Beth Blik
8 Danvers Road
London, England
081 340-5649
Page 87

John Bolle
1340 Madison Avenue
Bethlehem, Pennsylvania 18018
USA
Page 83

Lucio Bubacco
S Polo 1077/A
30125 Venezia, Italy
041 52 25 981
fax: 0039 041 5225565
Pages 16-17

Kathy Budd
Post Office Box 80621
Minneapolis, Minnesota 55408
USA
Page 89

John Cays
Route 8, Box 8131
Stroudsburg, Pennsylvania 18366
USA
717 629-1741
Page 83

Mark Cesark
886 Brown Road
Bridgewater, New Jersey 08807
USA
201 722-8499
Page 90

Erwin Eisch
D-8377, Frauenau
Germany
0 9926 189 242 200
Pages 10-11

Steven Feren
2601 C.T.H. MM
Oregon, Wisconsin 53575
USA
608 273-2218
Pages 12-13

Jan Fisar
Glasgalerie Hittfeld
Kirchstr 1
2105 Seevetal 1-Hittfeld
bei Hamburg, Germany
49 4105 52364
Page 49

Hans Godo Frabel
695 Antone Street Northwest
Atlanta, Georgia 30318 USA
404 351-9794
fax 001 404 351-1491
Page 50

Sammi Fraser
W 1401 Twin Lakes Road
Rathdrum, Idaho 83858
USA
208 687-2184
Page 91

Pamela Gazale
Post Office Box 14048
Seattle, Washington 98114 USA
206 322-0855
Page 51

Hans-Joachim Gerick
Robert Koch Strasse 8
8263 Burghausen, Germany
08677/64963
Page 92

Linda Gissen
973 Larkaway Court
Virginia Beach, Virginia 23464
USA
804 495-2653
Page 93

Julie Golden
580 Spruce Street
Boulder, Colorado 80302
USA
303 442-6355
Page 94

Mary J. Gregory
Kirkkokatu 11 A 23
SF-90100 Oulu
Suomi, Finland
358 81 224 199
Pages 96-97

E. Gail Guy
Post Office Box 494
Front Royal, Virginia 22630
USA
703 636-4835
Page 95

Eka Haeberling
1M Ziegelgut
3400 Burgdorf,
Switzerland
0041 34 22 04 54
Page 98

Jiri Harcuba
Janouskova 1
16200 Praha 6, Czechoslovakia
Pages 18-19

David Hopper
2902 Neal Road
Paradise, California 95969
USA
916 872-5020
Page 52

Suzanne Reese Horvitz
 Robert Roesch
2310 Perot Street
Philadelphia, Pennsylvania 19130
USA
215 765-3208
Page 56

Eduard Indermaur
Jurastrasse 5
CH-4242 Laufen,
Switzerland
061 89 12 01
Page 99

Vladimir Jelinek
U Okrouhliju 2
150 00
Praha 5, Czechoslovakia
52 30 18
Page 54

Martin Jiricka
Kladska 3,
120 00
Praha 2, Czechoslovakia
25 17 514
Page 100

Tony Jojola
Post Office Box 166
Isleta Pueblo, New Mexico 87022
USA
505 869-3769
Page 101

Kyochi Kamei
1-58 Oise-cho
Nakagawa-ku
Nagoya, Japan
052 352 9185
fax 052 352 9185
Page 55

Ronen Kandel
120 Uziel Street
Ramag Gan 52311, Israel
Page 88

Ludwik Kiczura
ul. Wlodkowica 27/18
50-072 Wroclaw, Poland
304 08
Page 102

Ireneusz Kizinski
Wroclaw
ul. Inowroclawska 48/3,
Wroclaw, Poland
Page 105

Toan Klein
280 College Street
Toronto Ontario, Canada M5T 1R9
416 960-9222
Pages 20-21

Vladimir Klein
Lidicka 811
471 14 Kamenicky
Senov, Czechoslovakia
04 24 92 487
Page 57

Lucartha Kohler
915 South Second Street
Philadelphia, Pennsylvania 19147
USA
215 468-0557
Page 103

Christoff Koon
1169 Gopher Canyon Road
Vista, California 92084
USA
619 941-8439
619 298-2684
Page 53

Kai Koppel
Fedjuninski 72-10
Tallinn 200036, Estonia
216310
Page 104

Therese Lahaie
726 Goldengate Avenue
Point Richmond, California
USA
415 233-5570
Page 58

Soren Staunsager Larsen
Bergnik 2
Kjalarnes 270 Mos, Iceland
1 667067 (666038)
Page 59

Edward Leibovitz
Jascob Jordaens 46
2018 Antwerp, Belgium
0032 3 2184036
Pages 22-23

Lizabeth Levine
5718 Sherman
Downers Grove, Illinois 60516
USA
708 964-4845
Pages 106-107

Stanislav Libensky/
Jaroslava Brychtova
Vodickova 41
110 00 Praha 1, Czechoslovakia
Pages 24-25

Maria Lugossy
41 Martirok Utja
H-1024 Budapest, Hungary
1162 901
Pages 26-27

Finn Lynggaard
Nedergade 19
8400 Ebeltoft, Denmark
45 86 34 35 66
Pages 28-29

Paul Marioni
4136 Meridian Avenue North
Seattle, Washington 98103
USA
206 633-1901
Page 60

Liz Marx
2271 Bancroft Avenue
Los Angeles, California 90039
USA
213 665-1742
Page 61

Ursula Merker
Haus Kynast
Gstaigkircherl 22
D-8420 Kelheim, Germany
0049 9441 3355
Pages 30-31

Karel Mikolas
RD3 Box 131
Slatington, Pennsylvania 18080
USA
215 767-2895
Page 108

Pavel Molnar
Am Bondenholz 15
2000 Hamburg-Barsbuttel,
Germany
040 710 20 53/54
Page 62

Hartmut Müeller
Rentzelstr 6
2000 Hamburg 13, Germany
040 410 29 76
Page 63

Roger Nachman
1473 Elliott Avenue West
Seattle, Washington 98119
USA
206 281-9406
Page 109

Vincent Leon Olmsted
2700 East Main Street
Millville, New Jersey 08332
USA
609 327-4725
Page 110

Robert Palusky
Route 1, Box 129-A
Deansboro, New York 13328
USA
315 821-6373
Page 65

Mirella Patruno
Viale Jonio n. 331
00141 Roma, Italia
39 6 8171662/8275962
Page 64

Kazimierz Pawlak
Prochnika 157/22
53-323 Wroclaw,
Poland
Page 111

Sibylle Peretti
Graffstrabe 2
5000 Koln 30, Germany
0221 519932
Page 68

Neil Roberts
55 Uriarra Road
Queanbeyan 2620, Australia
06 2975481
Page 112

Frank Root
45 West Mount Airy Avenue
Philadelphia, Pennsylvania 19119
USA
215 242-8213
Page 69

David Ruth
1122 57th Avenue
Oakland, California 94621
USA
415 533-8528
Page 72

Stefan Sadowski
57-320 Polanica Zdroj
Skr Poczt
Wiejskag, Poland
721
Page 113

Lubov Savelyeva
Vernadsky PR 95/2 Apartment 171
Moscow, Russia
117 526
Pages 32-33

Sem Schanzer
Lange Herentalsestraat 1A
Antwerp, Belgium
32 3 231 6831
Pages 70-71

Mary Shaffer
4200 Massachusetts Avenue
Northwest #915
Washington, DC 20016 USA
703 823-4413
Page 73

Alison Sheafor
433 Woodlawn Avenue
Topeka, Kansas 66606
USA
913 841-4950
913 234-4476
Page 116

Elly Sherman
2170 Linnington Avenue
Los Angeles, California 90025
USA
213 474-8278
Pages 34-35

Stephen Skillitzi
Post Office Box 377
Brighton, South Australia 5048
08 298 41 56
Pages 66-67

Erika Stephan
91 Webb Cove Road
Asheville, North Carolina 28804
USA
704 254-2559
Page 114

Robert Stephan
91 Webb Cove Road
Asheville, North Carolina 28804
USA
704 254-2559
Page 115

Jullie Steward
8728 Cliffwood Court East
Mentor, Ohio 44060
USA
Page 117

Raquel Stolarski-Assael
Bosque de Tamarindos 17-1102
Col. Bosques de las Lomas, Mexico
DF 05120
525 570 7262, 394 1319
Pages 36-37

Margaret Stone
Star Route #526
Madrid, New Mexico 87010 USA
505 471-1803
Page 118

Steven Tatar
620 El Paraiso Northwest
Albuquerque, New Mexico 87107
USA
505 345-4538
Pages 74-75

Thomas Tisch
Post Office Box 753
Trumansburg, New York 14886
USA
607 387-5473
Page 76

Steve Tobin
RD1 Box 404
Coopersburg, Pennsylvania 18036
USA
215 346-6058
Pages 38-39

Mihai Topescu
bul, Republicii, bloc 8, ap 10
1400 Tirgu Jiu, Romania
929 16856
Page 77

Dana Vachtova
Vaclavske namesti 33
11000 Prague 1, Czechoslovakia
0042 2 260178
Pages 78-79

Bertil Vallien
Afors 36104
Eriksmala, Sweden
07 71 41181
Pages 40-41

Bruno Van Dijck
Kuringersteenweg 62
3500 Hasselt, Belgium
011 25 3228
Page 119

Eva Vlasakova
Vranove II.c.144 468 31
Mala Skala, Czechoslovakia
0042 428 77 330
Page 120

Jan Votava
Zd. Fibicha 1203
757 01
Valasske Mezirici, Czechoslovakia
Page 121

Ilse Wagner
Bragevagen 13
43361 Partille, Sweden
031 261749
Page 122

Rolf Wald
710 Coastline Drive
Seal Beach, California 90740
USA
213 598-1508
Pages 126-127

Janusz Walentynowicz
Post Office Box 3792
Bloomington, Illinois 61702-3792
USA
309 829-5376
Pages 42-43

Shauna Walsh
08 Huntleigh Avenue
Fayetteville, New York 13066
USA
315 637-9345
Page 124

Irving Warhaftig
Post Office Box 3753
Santa Fe, New Mexico 87501-0753
USA
505 455-3533
Page 125

Elke Werchan
Bachstr 62-64
5100 Hachen, Germany
0241 506622
Page 128

Hans-Jurgen Wolff
St. Bonifatius Str. 2
D-8000 Munchen 90, Germany
089 6915701
Page 123

Dana Zamecnikova
Stodulecka 11
15800 Praha 5, Czechoslovakia
011 42 2 551165
Pages 44-45

Peter Zelle
1500 Northeast Jackson Street
Minneapolis, Minnesota 55413
USA
612 788-8089
Page 129

Jan-Willem van Zijst
Dennenstraat 6
3930 Hamont-Achel,
Belgium
011 642837
Page 130

Czeslaw Zuber
16, Allee Des Arts
94 230 Cachan, France
Pages 46-47

It is a great wonder

that I have not given

up all my expectations.

I still cling to them,

despite everything,

because I still believe

in the inner goodness

of humanity.

ANNE FRANK

This book was printed at Waldman Graphics in March 1992
and bound by Hoster Bindery.

The typeface used for the text was Electra set by The Studley Press
and printed on 110 lb Eloquence,
an acid-free museum reproduction paper by Potlatch.

The book was designed by Jonathon Nix
with special photography by George Erml.